THE PRODUCER'S PLAYBOOK:
Real People on Camera

The Producer's Playbook: Real People on Camera is a no-nonsense guide for producers looking to get the best performances from "real people" to tell powerful stories on video. Director/producer Amy DeLouise brings years of experience to this resource for creating the best on-screen impact with non-actors for interviews, re-enactments, documentary, and direct-to-camera messages. With useful case studies and tips on everything from managing locations and budgeting to strategies for managing crews and the expectations of executive producers and clients, this is an invaluable resource for professionals working in reality TV, documentary, corporate video, non-profit media, and more.

- Ample case studies with perspectives from industry professionals interviewed by the author, as well as her own plentiful stories from the field
- Tips are featured in sidebars throughout the text, so that readers can see how the information applies to real situations
- Full-color photographs allow readers to visualize real world production situations
- The appendices include useful templates and checklists for working producers

As an accomplished video director/producer with more than 400 productions to her credit, Amy is an expert at working with non-professionals on camera. Her more than 40 creative excellence awards include the Telly, Peer, New York Festivals, Aurora, and CINE Golden Eagle. She was also honored with the Woman of Vision Leadership Award from Women in Film & Video of Washington, D.C.

Amy is a sought-after speaker on a range of digital video topics at such industry conferences as the National Association of Broadcasters convention (NABShow). Her popular courses on Lynda.com include Script Writing for Nonfiction Video and The Art of the Video Interview. She has a B.A. in English from Yale University.

With *The Producer's Playbook: Real People on Camera*, Amy brings her no-nonsense style, real-world anecdotes, and passion for non-fiction storytelling to film students and experienced production professionals alike.

"I finally have a resource to teach how these stories can be made, instead of just a text on who made them. Once again, Amy has provided a resource that the beginner and the professional can learn from and reference often. I know my copy will be dog-eared very soon, and won't stay on the shelf too often."

—James Biddle, Senior Lecturer, Entertainment and Media Studies Department at The Grady College of Journalism and Mass Communication, University of Georgia

"Amy is a badass. It shows in her work. It shows in her relationships with her clients. It shows at every level of her career. This book is like a channeled, focused version of the stuff she does right. You owe it to yourself and your career to read this book."

—Kanen Flowers, Founder of THAT Studio, Director, Producer, world-renowned technologist and venture investor

"As an award winning film and reality TV producer I have learned how to work with real people through trial and error and years of experience but now, you can do it easily, with the help of Amy DeLouise's new book. Step by step, bullet proof tactics to coax a performance out of even the most stoic subject. Trust me, you need this."

—Adryenn Ashley, Award-Winning Producer and Founder of CrowdedReality.com

"Having booked thousands of crews in more than 110 countries for television and corporate producers, and now directing my own feature-length documentary, I can say Amy's book is insightful and informative for anyone in the film and video production industry. It's a must read!"

—Jay Schlossberg, Owner, Media Central LLC and Director, *Feast Your Ears—The Story of WHFS 102.3 FM*

THE PRODUCER'S PLAYBOOK:
Real People on Camera

AMY DeLOUISE

NEW YORK AND LONDON

First published 2016
by Routledge
711 Third Avenue, New York, NY 10017

and by Routledge
2 Park Square, Milton Park, Abingdon, Oxon OX14 4RN

Routledge is an imprint of the Taylor & Francis Group, an informa business

© 2016 Amy DeLouise

The right of Amy DeLouise to be identified as author of this work has been asserted by her in accordance with sections 77 and 78 of the Copyright, Designs and Patents Act 1988.

All rights reserved. No part of this book may be reprinted or reproduced or utilized in any form or by any electronic, mechanical, or other means, now known or hereafter invented, including photocopying and recording, or in any information storage or retrieval system, without permission in writing from the publishers.

Trademark notice: Product or corporate names may be trademarks or registered trademarks, and are used only for identification and explanation without intent to infringe.

Library of Congress Cataloging in Publication Data
A catalog record for this book has been requested

ISBN: 978-1-138-92049-1 (hbk)
ISBN: 978-1-138-92048-4 (pbk)
ISBN: 978-1-315-68693-6 (ebk)

Typeset in Akzidenz Grotesk and Franklin Gothic
by Keystroke, Station Road, Codsall, Wolverhampton

Printed and bound in the United States of America by Sheridan

For my dad, who taught me to love people and their stories.

CONTENTS

P XII **FIGURES**

P XVI **PREFACE**
Richard Harrington

P XX **ACKNOWLEDGMENTS**

P 2 **INTRODUCTION**

P 6 **CHAPTER 1**
GETTING TO KNOW YOUR SUBJECTS

P 24 **CHAPTER 2**
MASTERING THE BUDGET AND SCHEDULE

P 50 **CHAPTER 3**
LOCATIONS

P 68 **CHAPTER 4**
PLANNING YOUR STORY

P 82 **CHAPTER 5**
CREATING THE BEST ENVIRONMENT FOR REAL PEOPLE

P 96 **CHAPTER 6**
WORKING WITH CREW

P 102 **CHAPTER 7**
DIRECT-TO-CAMERA DELIVERY

P 116 **CHAPTER 8**
SHOOTING RE-ENACTMENTS

P 128 **CHAPTER 9**
BEYOND THE SOUNDBITE: THE DANCE OF THE INTERVIEW

P 142 **CHAPTER 10**
CHALLENGING INTERVIEWS AND ON-CAMERA SUBJECTS

P 150 **CHAPTER 11**
EDITING WORKFLOW STRATEGIES

P 166 **CHAPTER 12**
MANAGING CLIENT RELATIONSHIPS AND APPROVALS

P 176 **WRAPPING UP**

P 178 APPENDICES

Appendix A: Creative Brief Template — p179
Appendix B: Producer's Checklist—Approvals — p181
Appendix C: Asset List fot Edit Template — p183
Appendix D: Producer's Checklist—Pre-Production — p184
Appendix E: Producer's Checklist—Production — p187
Appendix F: Producer's Checklist—Post-Production — p190
Appendix G: Sample Mini Doc Budget — p192

P 194 GLOSSARY

P 198 BIBLIOGRAPHY

P 202 INDEX

FIGURES

Plan a "Matrix" of Real-People Characters	p7
Build Relationships through Pre-Interviews	p12
Camera Stabilizers Allow Walk-and-Talk Shots	p33
Hide Equipment Behind a Silk	p35
Add Motion with a Slider	p38
Busy Family Sample Shoot Schedule	p40
Sample "Dependency" Schedule	p45
Screen Shot Using Movie Magic Scheduling Software (Entertainment Partners)	p47
Crew on a Military Location	p56
Marines Dangling from Helicopter	p57
Fracking Documentary Title Screen	p58
Ebola PSA Shot in Home-Like Setting	p61
Getting Signed Talent Release	p65
Non-Fiction Story Arc Diagram	p69
Healers and Healing Location Photo	p72
Build a Shooting Schedule	p77
Automated Slider from Redrock Micro	p80
Hair and Makeup Boost Confidence	p87
Children Filmed in a Natural Environment	p90
Green-Screen Environments Require Confidence	p93

Crew with Direct-to-Camera Host in the Field	p99
Direct-to-Camera in Green-Screen Studio	p105
Standing to Speak Conveys Confidence	p107
PT-Elite-U Tablet Teleprompter	p111
Staged Discussion with a Documentary Subject	p121
DP Builds a Relationship with Subject	p122
Real People Re-Enact Preaching Scene	p124
An Interview is an Interactive Duet	p131
Interviewing a Child	p143
Shooting Script Marked for Edit	p154
Using ScriptSync™ for Avid	p158
Lumberjack System Transcript Mode for FCPX	p160
Sample Asset List for Edit	p162
Sample Creative Brief	p170

PREFACE

Richard Harrington

VIDEO IS A TRULY compelling medium. It can convey character, tone, and emotion. Need to make a convincing point or drive toward a goal? Video is the right choice. Want to change the world? You can. When you combine these strengths and bring a non-fiction message to life using real people, that's powerful stuff.

But it's really easy to screw things up. Choose the wrong voice and your video can lose its effectiveness. Mismanage folks and you can quickly move into high-stress territory. Working with actors is easy. It's the real people that scare me.

In your hands you are holding very valuable information. Amy DeLouise is one of the finest producers I know and a truly gifted educator. I've worked with her personally on many projects that documented history in the making, raised funds for important causes, and communicated passion. Simply put, Amy gets it. She's been there in the trenches for years.

We first crossed paths when I was a freelance video editor. Locked in a dark room, cutting videos for many of her clients, I found a kindred spirit who truly believed that as visual storytellers we have an obligation to serve the mission and causes of our clients. That doesn't mean that we always agree with each message, but it's critical to understand a client's or executive producer's needs, fears, and desires if a truly great production is to be created.

One of Amy's greatest strengths is that she doesn't just accept the pieces that she's given. She's learned to apply her background in music, theater, and film to the world of non-fiction storytelling. Amy knows that you must craft the story. It takes research, and role playing, and casting, and editing to get the results you need.

Throughout this book you'll learn what it takes to get real results.

- ***Chapter 1: Getting to Know Your Subjects.*** **This is a truly essential chapter. If you don't know the characters**

in your story, how can you create a truly compelling structure that holds the audience's attention?

- *Chapter 2: Mastering the Budget and Schedule.* Amy shares practical advice on what to budget for and where to avoid cutting corners. These days, budgets are tight, and it's essential that you understand what you have to work with as you start to produce your project.
- *Chapter 3: Locations.* Once you've got the characters, you need the backdrop. Chances are if you're working with real people, you have real locations too. These are often filled with challenges and this chapter helps you to navigate them.
- *Chapter 4: Planning your Story.* Creativity is great . . . but being able to turn that into a reality is an essential skill. Amy and her guests offer some important practical advice.
- *Chapter 5: Creating the Best Environment for Real People.* Creating an environment that is both comfortable and safe is essential for non-professional talent. Amy understands what it takes to run a set that is both creative and productive.
- *Chapter 6: Working with Crew.* Video is a team sport. Knowing how to run a collaborative set ensures that you get the best results from your team.
- *Chapter 7: Direct-to-Camera Delivery.* Asking your subjects to serve as on-camera spokespeople or hosts can get quite tricky. Amy shares practical advice on how to set up your subject to succeed.
- *Chapter 8: Shooting Re-Enactments.* You can't always document reality when it happens. Sometimes you have to re-create it. Amy shares hard-earned strategies to save your budget and avoid turning real people into bad actors.
- *Chapter 9: Beyond the Soundbite: The Dance of the Interview.* Amy is one of the best interviewers I've ever worked with, and it all comes down to preparation.

In this chapter, she shares information on how to get great interviews in the can.
- *Chapter 10: Challenging Interviews and On-Camera Subjects.* Don't let a tough subject throw you off your game. Learn strategies to get the best performance from your sources.
- *Chapter 11: Editing Workflow Strategies.* The magic often happens in post-production. Or . . . all the money gets wasted fixing problems. The relationship you build with an editor is essential to the results you want.
- *Chapter 12: Managing Client Relationships and Approvals.* You can't measure success unless you've agreed on a goal. If you want clients and executive producers to become raving fans who hire you back and recommend you, then you need to control the creative process.

It's time to begin. Open your mind to a new way of working. The task before you is a difficult one, but the rewards are many. Crafting stories and shaping the message mean that you have both tremendous opportunities and exciting challenges. You've got a great coach for the journey. Godspeed.

ACKNOWLEDGMENTS

THIS BOOK WOULD NOT have been possible without the support and guidance of many friends, colleagues, and family members. In particular, I want to thank Jack Reilly for his unflinching assessments of early drafts, and thoughtful suggestions. My editor at Focal Press/Routledge, Emily McClosky, was a superb resource as we developed ideas for the book. And my thanks go to Dave Williams, editorial assistant at Focal Press/Routledge, for all of his help with this project. And my grateful thanks also to Helen Lund, copy editor, for her eagle eye. Additional input was provided by sound recordists Jonathan Cohen and Lance Wells, producer Bruce Himmelbrau, and editing gurus Alex Gollner and Luisa Winters. I very much appreciate the ideas on edit workflow from Professor James Biddle at the University of Georgia. Thanks to Andy Collins for his marvelous drawings that capture reality production in a storyboard style. And to the colleagues whom I interviewed, who spent time discussing the art of producing reality—I am so grateful for your insights and expertise.

I've been lucky to count Richard Harrington, who kindly wrote the preface for this book, as my long-time friend and colleague. Rich, your invaluable advice and expertise have improved so many of our collaborations over the years, and your commitment to our industry has made it a better place for all of us.

I would be remiss not to mention the Women in Film & Video community in the Washington, DC area and my many talented friends and colleagues there, who have been an ongoing professional network and personal support system through the many iterations of my production career. Among these wonderful women: my long-time mentor and friend Beth Mendelson, who never lets obstacles get in the way of her producing some of the great "real people" stories of our time.

Finally, one can't live the producer/director's life, let alone write a book about it, without the support of a great partner. Thanks to my husband John Bader for being that rock. And to my boys Eli and Calvin, may you always find great stories wherever life takes you.

INTRODUCTION

I SAT IN THE beautiful main reading room of the Library of Congress, flipping through a decades-old copy of *Life* magazine. My project was to find the people, the stories, and the artifacts—protest signs, TV cameras, 1970s attire, cop cars—that could be re-created by the art department for a Vietnam War protest scene in a feature film I was working on. The film had a funny name, and my list of items to research was even more unusual—from ping pong tournaments in China to helicopters in Vietnam. The film was *Forrest Gump*, and it turned out to be one of the most amazing stories on the screen—and what a work to help create, in a very small way as a freelance art-department researcher. In addition to my time researching, I adored the days spent on set in Washington, DC, watching the pieces come to life. Yet when production ended, I realized that what grabbed me the most were the stories of the real people I had encountered along the way: the people in those *Life* photos, and on those White House archive reels, and in the many newspaper articles and magazine stories that became my life for so many months. Who were they? What made them tick? How did they come to be a part of history?

Real people have always fascinated me. And I've been lucky enough to build a career directing and producing non-fiction stories featuring hundreds of different people, from all walks of life. Prime ministers and pilots, soup-kitchen guests and elderly war veterans, cardiologists and nuns—theirs are the stories I've been privileged to tell. With these stories come challenges, many of them unique to non-fiction storytelling and working with "real people." For many years I've been teaching workshops at production conferences around the United States. For audiences from several dozen to several hundred, I share my insights and strategies for working with non-professionals on camera, in the scriptwriting process, and in the edit room. Questions about budgeting, scheduling, interview techniques, and story structure come up over and over again. And I know that means that even more people than just my workshop students are struggling to make their real-people stories better.

So I decided to share some of my own stories, as well as the strategies and thinking I have evolved over the several hundred productions of my career, in order to bring out the best from non-professionals on camera. This book is the result, and I hope you find it helpful as you continue on your own storytelling journey.

CHAPTER 1
GETTING TO KNOW YOUR SUBJECTS

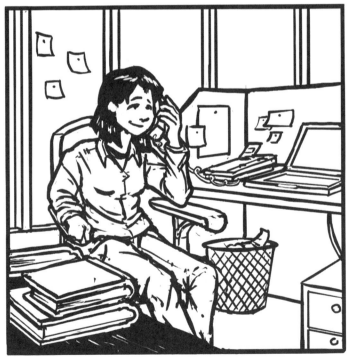

Andy Collins

CHOOSING YOUR CHARACTERS

IN NON-FICTION, REAL PEOPLE are the heart of the story. How you choose them, and how you build a relationship with them before filming, will affect your entire production. When faced with a complex or multi-faceted story to tell, think of all your opportunities as a "matrix," with the definition of matrix being "an arrangement of parts that shows how they are interconnected." Before we shoot, I need to find how those inter-connections work in order to make an interesting story. Cup of coffee in hand, I'll typically ponder this set of story possibilities using a whiteboard filled with potential on-camera subjects. Each one could fill a needed role in telling the story, but also might stand in for a particular audience perspective.

For example, in a story I produced about women experiencing discrimination in higher education, we whittled down our matrix from

Figuring out your "matrix" of people is the first step to non-fiction storytelling.

Credit: Amy DeLouise.

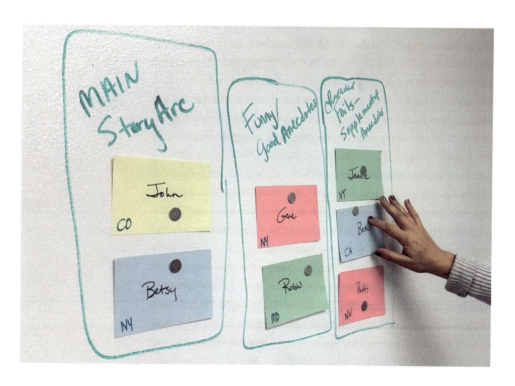

7

dozens of candidates across the United States. We ended up focusing on one high-level administrator, one department chair, one PhD candidate, and one professor. They were women with very different personal styles, yet they were all passionate about their stories and we thought they would be compelling on camera. They were also of differing ages, backgrounds, and came from different geographic areas. In this particular story, each woman provided her personal narrative, while also becoming part of a broader narrative about gender bias in education.

In any given matrix, you might have people who tell parts of the same story. Or they might represent opposing points of view on an issue. Each person brings a unique viewpoint to the content—geographic, gender, ethnicity, age, job type, or other life experience. A character might even serve as a foil to the main character in the story. In the film *Cain's Arcade*, one of my favorite mini-docs of all time, the father provides some of the narrative glue for the story, and the backstory on his son Cain. Besides being an important person in Cain's life, he provides a character foil for the idealistic and excited Cain with his real-world, low-key style. In a short historical educational doc I produced, we used a similar character-foil approach. The main character was a dynamic but also eccentric person. To ground the story, we sought out an interview with a professor who could provide historical context and serve as an outside authoritative voice.

Whatever your challenges and your matrix, it's a puzzle to be solved. Your solution needs to serve the story. So as you begin to meet your potential characters, ask questions. Not simply "What part of the story could this person tell?" but also "What style of storyteller is she?" and "What can help uncover facts about another character?" When you work your way through the matrix to the right mix of characters, you often "just know" you've hit on the right combination. Throughout the pre-production research process, try to build good relationships with all the potential characters. Even if they don't end up in the final on-camera group, they may help uncover essential facts, or provide valuable photos or footage. And, of course, make

no promises about who will be filmed until you are really ready to commit. That way, you keep your options open.

Pre-Qualifying On-Camera Subjects

The best way to cast any program, whether reality TV, educational, or documentary, is to stay focused on your story arc. Who is serving as the protagonist? If there's not an antagonist, *per se*, is there a character foil to keep scenes from becoming monochromatic? Are there validators who can support the main character's story? How will the central conflict or challenge unfold? Will people tell this story (together or separately), or will the narrator reveal it as some kind of dichotomy between characters and story lines? Don't let others determine your characters. I know there will be pressures. "We need to use this expert, who helped us on the last show." "We should really have a left-handed, conservative economist represented here." Or worse, "The executive producer's nephew is super-cute and will be great on camera!" If at all possible, bring your editor and your executive team into the world of your prospective matrix. Put the show goals at the top of your chart or whiteboard. Show them all the possibilities, and what perspective or texture each character could bring to the story. This is just as true for re-enactments as it is for on-camera delivery or interviews. Ideally, you want to choose from the best of the best, not from the least bad of the terrible.

On reality TV shows, it's common to look for characters who make a big splash on screen. Pre-qualifying Skype interviews may be quickly followed by some informally taped discussions to see who's got charisma. Character reels are often assembled by the production company in order to assess each potential on-camera subject and how they might fit or contrast with one another as a full cast. In his article in *The New York Times*, "Donald Trump, our Reality TV Candidate," reality TV producer Seth Grossman explains that he can tell in just 30 seconds of a Skype interview whether someone will be the right kind of larger-than-life character for a slot on a reality

TV show. He describes passing up a fascinating subject who sold custom-armored vehicles to African warlords because he was too soft-spoken and self-aware to make a good reality TV character.

Casting is a two-way street. You are looking for someone with charisma whom viewers will find engaging, but also someone with whom you can develop a relationship over time. For the show *True Crime*, producer Benjamin Adams Trueheart casts by making cold calls to investigators.

> **I get a sense of how willing they are to just talk, whether or not they give simple yes/no answers. If someone is of interest, I build rapport with them through ongoing dialogue—in phone calls, emails— for weeks, even months. I want them to feel as comfortable as possible about the show.**
> (Truehart: interview, February 13, 2015)

In an interview with Terry Gross on NPR's *Fresh Air* (NPR, July 8, 2015), filmmaker Asif Kapadia talks about his extensive audio-only pre-interviews with the people featured in *Amy*, his documentary about singer Amy Winehouse. Asif describes how he built relationships of trust over the course of researching the film, and in doing so, received unique home videos, photographs, and other material to help him tell the story of Amy's life. In the same interview, we learn about the flip side of the interview relationship from Nick Shymanksy, Amy's first manager, who appears in the film. He talks about how he was initially against participating in the project. What changed his mind was meeting Asif and his team, and seeing their extensive research into her life story. Building trust and developing this two-way relationship are critical to effective storytelling.

Whatever type of project you are producing, and whatever timeline you have in which to do your research, you will want to become as

comfortable as possible with your key characters as human beings. That's really the joy of working with "real people" on camera. It's a gift to meet so many different people, and be trusted with stories about their lives. People will often surprise you. Occasionally those surprises won't be happy ones. But mostly, as the control freaks we tend to be in this business, we need to embrace the relationship-building process that goes beyond casting to something more personal, more real. When you vest this process with the importance it deserves, when you respect your subjects, then the storytelling has already begun.

Casting Children

When "casting" a child—whether for an interview, a re-enactment, or a direct-to-camera situation—you must cast the parent too. Believe me, for every child who wants to be on camera, there is a "stage mom" (or dad) behind them. This person will either be fantastic to work with, or a nightmare. There doesn't ever seem to be something in between. For me, the best and only way to cast children is in person. You need to meet the child, and you need to meet the parent or guardian involved. I like to set aside an intimate physical space for our first interactions together—a couch or living-room setting, rather than an office. It's important to talk, but also to listen; watch the dynamic between the parent and the child. You'll learn right away if the child is really interested in participating. This is the exception to the rule of the phone pre-interview which we discuss in a moment. In person, you can get a pretty accurate read on whether or not the parent will be easy to work with, will be prompt, can get to the shoot location, and if they've got any major concerns you can't resolve. Parental concerns can include everything from the child missing too much school (usually solved by creating a later start time for their appearance) to their child not receiving sufficient compensation (which you may or may not be able to solve; in some productions, you can't pay people to participate because it is unethical to do so). I once produced an educational show with a cast of real kids, and

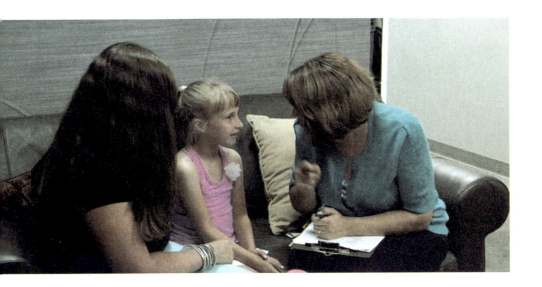

Pre-interviewing children means building a relationship with both child and parent.

Credit: RHED Pixel.

one parent was so problematic that sadly, we had to remove their child from the show. The parent had too many stressed interactions with her child, and was almost always late for every run-through and taping. It started to affect how the other children felt and interacted. Looking back, I realize that a member of my production team had flagged this potential problem during casting, and I could have saved us—and the child—some headaches by acting on that information from the start.

Casting for a Direct-to-Camera Read

The direct-to-camera read brings out the best, or worst, in non-professional talent. Unfortunately you may not know what will happen until you are rolling. But there are a few ways you can be better prepared. If this person gives regular speeches, try to watch some footage of one or two. It could be shot with an iPhone. The quality isn't important. You want to know a few things: Do they like to get out from behind the podium, walk around, and interact with the audience? Do they grip the podium as if they are hanging on for dear life? Do they need notes? Have they ever used a teleprompter? (Are

you going to use a teleprompter or expect them to speak extemporaneously directly to camera? Oh dear, please say you aren't going to try that.)

If someone grips the podium, you have your work cut out for you. You'll need to do their read seated, possibly in a higher chair with good arm-rests and an apple box or two for the feet, so that they can feel more authoritative than when seated in a low chair. For people who are accustomed to speaking to a room, the biggest danger zone you will have on set is that they will view your crew as their audience. They will glance around. They will forget to keep their eyes on the true audience by looking at the lens. As a result, you'll have "shifty eye" syndrome. So if you have an audience-oriented person, you know right away three things you'll need to do on set:

1. Keep crew from making eye contact.

2. Spend time helping them to imagine their true audience, just beyond the lens.

3. Have them deliver their talk standing up.

I don't know why, but for many people accustomed to public speaking, this helps to keep their delivery up-beat and to the point.

Casting Re-Enactments

One of the most challenging environments for non-actors is a re-enactment. What do I mean by re-enactment? What comes to mind is hundreds of people in period costumes, re-enacting a scene from the Civil War. Yes. But a re-enactment is also that short scene of b-roll in your production that results from you asking someone, "Could you please open the front door again?" In this brief moment, you are asking a non-actor to do a re-enactment. And planning for successful re-enactments with real people takes a bit more work

than you might expect. The biggest challenge you have to overcome is the notion that because the re-enacted scene is something the person does every day, somehow, magically, they will be able to do or repeat this action naturally in front of the camera. Cinematographer Richard Chisolm says he can always tell when a "fake moment" has been re-created on a shoot, and tries to avoid putting real people into situations that will make them fail.

> **You've got a guy in a low-budget re-enactment. He's wearing a costume. He's got to walk in a certain path for the camera. The last thing you want him to do is say "I'm here to see General Billingham." The audience will say this is cheesy. Use the narrator.**
> (Chisolm: interview, May 13, 2015)

He's got a point. Let the subject focus on one aspect of your production—either some kind of action, or something they would naturally say, rather than a specific line of dialogue.

There are a few exceptions to the rule about having non-actors "re-enact." I've found that people who work in noisy, stressful, or equipment-filled environments, such as emergency room (ER) nurses and surgeons or workers in a factory, can usually handle re-enactments without breaking into a sweat. Since they already work in an environment in which they must filter out external distractions to focus on what's truly important, they aren't thrown off by additional equipment and personnel. But for most people, doing something they do every day once the cameras are on feels unnatural, and that awkwardness can translate onto the screen.

So to help them—and you—be prepared for your re-enactment, and so you can figure out how you might best accomplish your story goals, you'll want to do the equivalent of a pre-interview. Even before conducting a location scout, which we'll discuss in detail in

Chapter 3, you'll want to get a handle on what this scene or scenes might look like. You can ask your program subject to shoot some cell-phone footage of their day, so that you get a sense of where your challenges are going to be. The obvious exceptions to this are re-enacting emergency response, or re-enacting medical events like surgeries. But even here, there may be surprising sources of footage that you can rely on to get a sense of what might happen. A hospital I work with tapes surgeries for educational sharing with medical students. In my city, we have crisis response drills which are usually taped for educational reviewing. And of course, YouTube is filled with civilian footage, so to speak, of just about every activity you can imagine. So take advantage of opportunities to plan ahead for your shoot day.

There are other challenges when trying to re-create a scene with non-actors. It's often common to find your subject is unwilling to re-do a "moment" for the camera. I had one interview subject who said she just couldn't place a phone call unless it was to a real person. I was somewhat prepared for this, as I had spoken extensively to the person, and built a relationship over several months of background research and emails. I knew she was both a very literal person and an experienced corporate executive who would want a detailed schedule, with a very specific list in advance of any "re-enactments" we might be doing. We were able to provide this well in advance of shooting, so she could alert other non-actors in the story that they might be called upon to help us re-create some scenes.

When It's Unwise to Cast or Pre-Interview

There are times when a director needs to roll with the moment, and pre-casting or pre-interviewing can ruin the magic. How do you know? Sometimes it's the context for the film that dictates this decision. Sometimes it's the content. For example, for a documentary about Catholic women religious working in Appalachia, our main

characters were the sisters, who I learned were not called nuns during my extensive pre-interview process well in advance of our shoot. But the main focus of the film was their impact on poor and underserved communities. The people they worked with were critical characters in the film, and yet they were also very suspicious of cameras and anyone with a release form who might seem like "the government" coming to take something from them. I had to trust my main subjects to know their own community, and to choose who might both best represent all the people served, but also be willing to be filmed. The one thing I could do in advance was to be up front about how much equipment we would or wouldn't bring—minimal camera and sound equipment—and discuss ways to make the experience less intrusive for people. I also was very careful to select crew who were friendly, down-to-earth people comfortable working in a wide variety of documentary environments. We also asked one of the sisters to collect the release forms—which were extremely short and not legalistic— since they knew the people personally and could explain the project. A few weeks before the shoot, we discussed the main goals of each scene in our shooting schedule, which helped my surrogates choose a marvelously varied group of subjects. In the end, we filmed a lively fellow who was a regular at a soup kitchen, and a memorable elderly woman rocking on her porch, who became a great validator for the entire community of sisters. We also shot an unforgettable scene with a family with five children living in a small, two-room house. One of the young boys had one of the most memorable lines echoing the theme of the whole film: "Wherever you go, that's where the sisters are." This emerged from an impromptu interview that one of the sisters actually conducted with the boy as we rolled. In the world of real people, if you plan to have extra time in your shoot days, real people can unfold before you in wonderful ways that an over-scheduled shoot will never achieve. The best you can do is to be ready for their stories, and have a good framework for how these can fit into the narrative structure of the whole.

BUILDING A RELATIONSHIP

Working in front of a camera is an intimate affair. Even the most seasoned actor can break into a sweat when the full focus of the director and crew is on them, not to mention lights, mics, and cameras. When subject and director have a comfortable working relationship, the experience—and the footage—improve. This is widely known in the narrative fiction world, in which actors and directors often spend time getting to know one another well before the cameras roll. But in the "real" world of documentaries, news magazine shows, reality TV, testimonials, educational and advocacy media, for some reason we have less of a tradition of making time (or assigning a budget) for relationship building. And yet, I've found the need to build this rapport to be even greater when I'm working with non-actors. I might be interviewing someone about their life's work, or shooting a medical re-enactment with surgeons who operate every day, or directing an experienced speaker to deliver one of their talks directly to camera. In each instance, it's amazing what a difference it makes when the subject and I have had a little time to interact before the cameras are turned on. In the real world, that interaction time might be very short—just moments together as we are walking to the room where the crew is set up. Or it could be months of interactions as we are discussing the content of a show, and both preparing for an on-camera interview. In either instance, there are definitely ways I've found for being better prepared, so that the footage feels both real, but also relevant.

So how can you best prepare for working with your subject? Are there situations for which you could be over-prepared, and ruin the spontaneity of the moment? Are there other situations when there could be some key to unlocking a more compelling "performance"? As a director, you'll find your own balance, and learn what works best for you in different situations. You'll also learn how to pick up on cues from the various types of people you will work with over the course of your career, and know what might serve them—and your story—best. Let's take a look at a few common reality situations and see how your preparation might work.

Dos and Don'ts of Preparing for an Interview

1. *Do conduct a pre-interview*. Do it by phone, at least initially. I always try to conduct a pre-interview by phone, a minimum of 2 weeks before the shoot and preferably months in advance. The reason for the distance of time is not only to help you plan, but also to avoid the "as I told you yesterday" problem once you are rolling. A minimum of a few weeks ahead puts this conversation far enough away to avoid any such references, but still gives you a little bit of time to prepare for your on-camera interactions. You might be tempted to conduct your first pre-interview in person. Don't. Here's why: Most people will be more honest with you over the phone. They are more inside their own heads than when they can be distracted by or influenced by your in-person reactions. And don't go using Skype or Google hangouts, as that's the same as the in-person experience. Remember that your subject may feel especially stressed about certain aspects of their story. It's likely these are the very parts that are most interesting to you as a filmmaker. And regardless of the type of interview you are conducting, whether it's a more confrontational *60-Minutes*-style investigative piece or an expert analysis for a documentary, you're definitely going to want to know what issues will be tricky so that you have some plans for navigating those moments in front of the camera.

2. *Do record your pre-interview, with permission*. Another great tool with a phone interview is the recording, which you can then have quickly transcribed. Most conference-call services offer this option, and you'll immediately have a downloadable mp3 file to send off to your favorite transcriber, or you can do it yourself. While your cell phone can probably record a call, your discussion may exceed the maximum size of the recording allowed, so using the "old school" services often works best.

You must of course disclose that you'd like to make a recording for your reference notes. I find that most people are fine with this, and happy that you are being accurate. For the few who aren't, it's not a deal-breaker, and I'm a very fast typist, so I can take my own notes while muting my phone or wearing a headset, so that the typing isn't a distraction.

3. *Do find out your subject's back-story, plus other stories—good, bad, and ugly.* Your pre-interview, and other research, will help you delve into your subject's background. This is not necessarily information for the screen. But it will help inform how you frame your questions, and give you a true understanding of his or her point of view. Your pre-interview also gives you time to find out the stories your subject is likely to tell. It's essential that you hear those stories which might suck up all the air during your interview, and which have no place in your piece. But by letting the subject tell those stories now, before you are burning through your budget, you can give them their due, and be ready to gently (or rigorously) redirect if they come up while you're rolling. I often say I like to "think like an attorney" when I'm researching my subject. That doesn't mean I'm planning to grill someone as if they are on trial. It means I don't like to ask a question with the camera rolling without having some sense of the answer. So take good notes, or make highlights and annotate your pre-interview recording. Buried here are the nuggets of your narrative—the treasures of first-person moments that you can now draw out on camera to make your story come alive.

4. *Do talk to "validators."* Use multiple background human sources on your subject. I call these folks validators because they can flesh out your story research on your central character, and possibly share some insights about them that they wouldn't feel comfortable saying about themselves. Sometimes a validator is

so wonderful you will decide you need them in your on-camera story. A spouse, a student, a long-time assistant, a pastor/imam/rabbi, a colleague, a friend— these are all great possibilities as validators. So the work of finding and speaking to these people is well worth the time.

5. *Don't miss reading articles, blogs, and book or research summaries.* This seems self-evident. And yet I've often watched people be interviewed by those who haven't "done their homework," and you can feel them cringe right through the TV screen when they are asked something that seems obvious. Doing your homework not only helps your production, it shows respect for your subject. They will respond with better stories and more comfort in your conversation on camera. They might even surprise you with something truly interesting or inspirational, which they wouldn't have revealed to someone they think is an idiot.

6. *Do learn biases and concerns.* Everyone comes at your topic differently, including your interview subject(s). Make sure you have a good idea of their particular points of view, and any special biases they bring to the table. It's not that you want to avoid these. But knowing them ahead of time will help you to design your interview and the flow of your narrative story. A particularly difficult bias might even make you choose some additional characters for comparison or contrast in the story.

7. *Don't antagonize gatekeepers.* As producers, we typically view gatekeepers as people we need to "get through" rather than get along with. In fact, we should try to see the world from their point of view. Typically, they are trying to protect someone or something. (That something might be their job. Everyone needs a job.) I recently directed a shoot with an executive at a major Hollywood studio. Talk about a place with gatekeepers. Even the gatekeepers have gatekeepers! Remember, gatekeepers

aren't just for the rich and famous. An adult child might be very concerned about his elderly mother being too tired out by appearing in your production. A handler may be worried that a performer might get distracted before an upcoming concert. The concerns may or may not be legitimate, but the gatekeeper is very real, and can derail a major investment for you and your crew unless you get a handle on what this person needs to feel comfortable. Respect gatekeepers, and develop friendly ways to interact with them whenever possible. Sometimes they are just protecting the brand of the featured interview subject. Sometimes they are protecting their turf. What you learn in the pre-production phase will help you on set, as you'll find out in Chapter 2.

8. *Do ask for visual assets during your pre-interview.* One of the great opportunities of the phone pre-interview is to discover whether your interviewee has photos or footage that might be useful to your production. I've uncovered everything from old family photos from World War II, which we later scanned while taking breaks to off-load footage, to beautiful artwork that I was able to plan for shooting while on location. Every bit of information you can glean may uncover some hidden treasures, which in turn can give you ideas for b-roll (supplemental footage that supports the main story) or even important new story lines for your production.

9. *Do cover "what to wear" and other shoot logistics.* You don't want to spend too much time on logistics, as you can follow up with an email afterward. But people always want to know about how they should look, how much time it will take, where they will park, and more. By using your pre-interview call to acquaint them with your expectations, or chat about options, you are drawing them into the creative team and making them feel less nervous. I know it sounds obvious, but again, because these folks aren't pros, your discussions on the call can

help allay any hidden anxiety they have about appearing on camera. You can also uncover any surprises: Like the fact that they just broke their leg skiing and won't be able to do that standing interview you had imagined.
10. *Remember, I don't recommend a phone interview for children and their parents.* This is always best done in person, to understand the relationship dynamics.

The Pre-Interview Payoff

The most important goal of your interview is building a narrative arc. By pre-interviewing your subject(s), you have a fighting chance of planning for that arc before you get on set. Does a pre-interview mean you will never be surprised? No. Does it mean you'll be prepared when that surprise comes, because you have the full context of the whole person appearing before you? Yes. Plus, the pre-interview gives you a personal connection before the moment when you both arrive, slightly stressed, on set. Because you've interacted before, the small talk at that moment can now be genuine. So you ask how the kids are doing in school *because you actually know their kids' names and what they're doing in school*. Or you talk about your subject's recent vacation with their aging parents because *you know where they went and why it was such a big deal*. These human connections will translate directly onto the screen when your cameras are on, trust me.

CHAPTER 2

MASTERING THE BUDGET AND SCHEDULE

Andy Collins

NOTHING PUTS A DAMPER on the creative juices quite like a spreadsheet. Yet the budget, and the process you use to create it, can have a very real impact on your creative options and outcomes. In production, there are always multiple variables that you can't control. Frankly, that's part of the fun of the medium. Add in the variable of working with non-professionals appearing before the camera, and you have a potent cocktail for budget disaster. Don't panic. There is one area where real people on set will affect your budget most. As with algebra, if you can solve this one variable, you've got an equation that works. So what is the variable you need to address? Time.

THE BUDGET AND SCHEDULE TANGO

Money and time are interconnected in production. We would always like more money to work with on a project. More time can help to keep a budget down. But we're also always battling time. The budget and schedule are often like a see-saw; a drop in one can send the other flying. When working with untrained subjects, the very thing that we love about them—namely, their natural and unpolished presentation—is the same quality that can pose challenges to both schedule and budget. In reality TV, or what is often called scripted television, some characters may be thrilled with the spotlight, and have experience before the lens. But not everyone will have the same comfort level as, say, Kate Gosselin and her children, who literally grew up in front of the cameras. Even when subjects bring on-camera experience, their presence can have unintended schedule and budget impact. Planning in advance will help to make your schedule realistic, and your budget manageable.

MINIMIZING THE SCHEDULE IMPACT OF NON-ACTORS

In an episode of *The Dick Van Dyke Show* ("*Boy #1, Boy #2,*" CBS, 1965), Rob casts their son and one of his friends in an episode of his TV show. The results aren't as anticipated. He confesses to the two moms: "Those kids can't act, they're terrible . . . When they started out they were almost fair, but the more they rehearsed the worse they got!" When the moms remind him that the kids aren't professionals, he responds, "Yeah, because professionals get better!" So true. One of the big differences between trained and untrained talent is that repetition and self-consciousness about being in front of cameras and crew often degrade rather than enhance non-professionals' "performance." And each time you make your reality player self-conscious about the camera, chances are that they will be less natural—the very quality you wanted them for in the first place. This, in turn, can radically affect your schedule and budget. In other chapters, we address specific techniques for re-introducing a question during an interview (Chapters 9 and 10), for blocking a re-enactment (Chapter 8), or getting that scene from another angle for a documentary (Chapter 4), all without making your subject feel awkward. To keep your production schedule and budget on target, you need all the help you can get to minimize retakes and set-ups. Even if you are masterful at keeping your subject from feeling pressure during the shoot, every minute you spend in shoot planning will be paid back in decreased time and costs on the post-production side. Since you never entirely know how a "real person" will react to being on camera, the following are some strategies you can use to minimize unpleasant surprises while you maximize creative opportunities.

Have Options for On-Camera Clothing

In pure documentary, you want subjects to appear just as they are, despite any challenges for the camera or sound. When I worked in

features and commercials, the wardrobe department would gently "tea-dye" anything white to a slightly duller shade to avoid challenging contrasts with darker clothing or skin tones in the scene. In a real-world hospital documentary, doctors will be wearing screaming white lab coats and you can't do anything about it. There may be other instances, though, when you can minimize the negative impact of clothing on your schedule and budget. Any small control over wardrobe you can have up front—even if this is only emailing examples of "what to avoid" to your prospective interviewee or subject—may save you considerable time making adjustments to lighting, lens, microphone and camera position choices in production, or help you avoid costly color correction time in post-production. Since most "civilians" won't understand how clothing appears under the lights and lenses, don't scare them with too much detail. Just offer ideas for options that will make them look and feel their best. If you can include a stylist in your budget, that day rate can more than offset costly work-arounds on set and in post-production. In the real world, people may need to wear a particular pair of pants, a uniform, or they might be someone who doesn't own a lot of clothing options. You never want your subject to feel bad. But you do want them to look their best, and to avoid costly time lags on set. In general, you can apply these basic rules to wardrobe for camera. And perhaps "rules" is too strong a term. Let's call them "goals."

Goals for On-Camera Clothing

1. *Avoid clothing that wrinkles easily.* Wrinkled clothing will make it challenging to shoot scenes discontinuously; a person's shirt appears wrinkled at the beginning of a scene, then miraculously gets unwrinkled later in the sequence. That can be an awkward issue to cut around during your edit.
2. *Avoid silk ties and scarves.* These will rustle under a lavalier microphone and cause sound editing challenges in post-production.

3. *Avoid embarrassment.* Some women's tops will become essentially see-through under lights. Some fabrics show sweat more than others. Polyester and rayon are particularly awful fabrics for sweaty people.
4. *Have your subject bring options.* If you are not purchasing clothing for someone acting as an on-camera host, for example, then encourage subjects to bring several colors and options with them on the shoot day. Tell them more is better—even if they feel like they are bringing their whole closet.
5. *Put your request in writing.* Of course, folks don't always listen. I had a lengthy pre-shoot conversation with the host of a show we were shooting on a virtual set— i.e., in a green-screen environment. I explained about avoiding the color green as well as white and black, and suggested that her coloring would work well with jewel tones. She agreed to bring several jackets to try for her scenes behind an anchor desk. The day of the shoot, she arrived with three suits. All of them were black. We had to stop the shoot and deploy someone to pick up additional options from her house, delaying the start time for those scenes. Luckily, we had other scenes to shoot, and someone available for the run.
6. *Avoid sparkly jewelry.* I love people to have their own personality on camera, and for women, that includes their own jewelry. But I also don't want it to become a distraction—especially when shooting in a green-screen environment, where shiny objects can interfere with a good key. Ask your subject to bring options.
7. *Avoid busy patterns.* Now that we are shooting digital, some patterns have become less of a problem. Several years ago, I used a Panasonic AF-100 to shoot an interview with a woman wearing a jacket with an M. C. Escher-type pattern of black and white. This would have killed us with a terrible moiré effect just a few years earlier, but the larger micro 4/3 image sensor on this

camera provides better latitude. I should add that my Director of Photography (DP) knew how to light a scene properly and evenly, which makes a big difference. Many of today's top cameras have a Super 35 sensor with even better latitude. According to DP Matt Gottshalk, "The difference between shooting on a DSLR and a purpose-built video camera is that the video cameras usually have an Optical Low Pass Filter which blends the small details like herringbone patterned shirts together, thereby reducing moiré but still retaining sharpness."

8. *That doesn't mean you shouldn't still be careful.* I've found some fabric weaves, even ones without a color pattern, can present a moiré problem. I had that problem on a recent shoot with the Sony A7S, which has a marvelous full-frame sensor. So checking under the lights and having options is always the best solution.

This brings me to my two key strategies for minimizing scheduling delays and their corollary budget problems: adding people, and adding shots.

Add Crew

This may seem counterintuitive, but adding people to your production team will actually reduce costs. Some of your lowest day-rate team members will have the most beneficial impact on your overall production budget. Interns, production assistants (PAs), and grips are invaluable. A PA can be dispatched to buy extra ties for the gentleman who didn't bring any options. An intern can help keep down noise in a corridor near an interview location, saving precious extra takes. A PA can bring the crew coffee, pop extra quarters in a parking meter, or investigate that pounding noise suddenly coming from the other side of the room you just lit for an hour. A grip can move gear to the next set-up location, get stingers (extension cords) run, and start roughing in lights. These are all enormous time-savers

that add up to hours of work, and hundreds or even thousands of dollars in overtime or added shoot days. Most vitally, though, additional people help to save everyone's creative energies for the important project at hand because added delays mean dollars for you, but they also add stress for non-professional subjects, who are not accustomed to the "hurry up and wait" life we lead in production. Having the right team in place will bring added peace of mind to you, and that confidence will translate to your on-screen talent.

Plan for Shooting "Interstitial" Scenes

Children are some of the most beautiful on-camera subjects to work with. They are unflinching in their honesty, and natural in front of the camera—particularly today's digital generation. But non-actor kids do pose challenges for your budget and schedule. They can tire of being the focus. And very young children need breaks for food and naps. When working with any subject, but especially young children and families, construct your schedule so that you have some breaks from the main shot list and can spend time on a few brief "interstitial" sequences. These do not replace your establishing shots, cutaways, and other sequences you need for your story. But these little sequences can be life-savers in post-production, both for their storytelling value and for helping editors get around challenging moments with on-camera subjects. I like to design these brief shot sequences as their own "mini-movies" that convey the essence of my main character and story. When edited together, they can also give viewers a visual break from the main sequence. During production, these shot set-ups also serve an important role: giving your real-people subjects a break, since they are not needed for these shots. Here's an example. I was shooting a scene with a young family who had both a small baby and a toddler. During our shot planning, my DP and I discussed a concept for a little montage that could convey life with babies. As we loaded in our gear, we noticed baby bottles drying on a rack in the kitchen. We decided to create a visual moment with these, as well as some bowls and other kid

paraphernalia on the counter. We kept the idea for this scene in the back of our minds, and when the baby needed a break from taping, we grabbed our moment. In the final production, it is a lovely little interstitial scene that establishes the story's characters and their life together. It also bought us essential coverage in the edit. When scheduling in real environments with real people, add slots in your schedule for a few interstitial moments each day. They will afford your talent a much-needed break, and you will have a shot sequence that helps move the story forward.

Get Good Audio

Audio often gets short-changed in reality productions. In a fiction production, actors are paid to say lines, so it's obvious that getting these lines is paramount. In non-fiction, we often forget that the most genuine moments are small but meaningful interactions between characters, and we can't afford to ask them to "say it again." It will never sound the way it did the first time. And they will immediately become self-conscious of our production process. If you have many different interviews or shooting environments, then adding some money for audio post-production will be money well spent. Audio sweetening hourly rates are usually lower than video editing rates, and the work goes faster using Pro Tools rather than various audio tool add-ons for your edit system. We will talk more about the workflow and strategies for audio post-production in Chapter 11 on editing workflow. For now, we'll just say that budgeting for an experienced sound engineer in the field, and potentially also using a sound editor to help in post-production, may help you grapple with the unique field sound issues that often arise from working with real people, such as pasting together and mixing different takes of an interview. Your story will be stronger with the addition of these two valuable audio experts on your creative team. If you must use a camera mic, mount a decent enough microphone to actually pick up natural sound. If you want to build audio mixing and sweetening into your post-production budget, plan on 4–8 hours of audio sweetening work for every week

of video editing, depending on the complexity of your material: how many channels of audio, how many different sources, how challenging the sound environments are in the field. "I usually get 32–40 hours to do an hour show, including reviews, outputs and cut downs, or sometimes more depending on the sound design needed," says experienced broadcast sound engineer Cheryl Ottenritter, owner of Ott House Audio. For a project where the audio is less challenging, she can mix a 45-minute program in 2–3 days. Sound design and mixing rates vary, but generally plan on $250 per hour as a base rate.

Plan for Transcripts

Build transcriptions into your post-production schedule and workflow, and see the direct impact it has on your post-production schedule and budget. How? Whether you are conducting interviews, shooting a re-enactment with dialogue, or have b-roll which includes live dialogue, being able to identify the precise segments you need dramatically reduces time spent scrubbing through footage. Being able to tag footage with key phrases in your metadata panel will also mean that tag lives with your footage across projects and platforms, so you can find key clips again easily. Having accurate transcripts also speeds up the process of closed or open captioning, which is now required for many productions. Transcripts can be done with or without time code, and typically run at $2 per minute. So for a few hundred dollars, you can have hours of audio material at your fingertips. You can find transcriptionists anywhere there are law firms. For more details on audio and edit workflow for transcripts, see Chapter 11.

Plan to Shoot Subjects "Talking while Doing"

Most people talk while they are *doing something else*—driving, walking, eating dinner, chopping vegetables, whatever. So a strategy you can use to maximize your production schedule while minimizing

CHAPTER 2
MASTERING THE BUDGET AND SCHEDULE

the budgetary liabilities of working with real people is to plan for shot sequences, and even interviews, that can be conducted while the person is doing something they are very comfortable doing. This has the extra benefit of serving to distract them from the unnatural aspects of filmmaking; namely, crew and equipment wherever they look. In the PBS documentary *The Italian Americans*, Lou DiPalo talks about his family's generations-old food business in New York's Little Italy while he makes the family's famous mozzarella. He stirs the vats, and forms the soft cheese balls just as he has done thousands of times before. And he tells the story of his family business. It's a wholly natural interview that draws us as viewers into his world. I've found that this technique works both with folks who seem a little nervous on camera and those who are naturally magnetic on camera. When shot planning, I do my homework to figure out which activities we can build into the schedule. These shots give us some additional cover b-roll for narration, and sometimes also yield added interview snippets. Once I followed a busy rabbi on his daily schedule. He

Camera stabilizers allow you to walk and talk with a subject.

Credit: *Courtesy of Fur Face Film/Her Aim Is True production.*

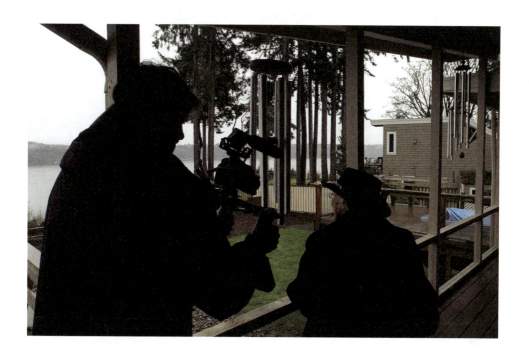

33

needed to attend several meetings, some of which were not part of our shoot schedule. But we loaded into his car anyway with the handy portable Kino Flo 9" Mini, and shot some dynamic scenes of him driving and talking. These worked well as transitions to our other scenes, and also gave us some important content not covered in the sit-down interview. As a bonus, we captured images while en route to a location—a slot in the schedule that is normally unproductive.

Use Locations Familiar to your Subject

You don't want your on-camera subjects to have a passing thought about your budget. On the other hand, your story and budget outcomes can be greatly improved with a few pre-shoot conversations between you and your subject. Take time to understand the spaces in which your featured people are most comfortable. As a corollary, learn where they are clearly uncomfortable, so you can avoid these spaces or situations. Ideally, you will make your location decisions well in advance, during your research and location-scouting phases, rather than on your day of shoot. But if you must make an on-the-scene judgment, walking around a location with your subject (away from crew) may give you clues as to where they feel most at home.

Consider constructing primary scenes, dialogue, or interviews in a place where your subject feels confident and comfortable. For an executive, it might be in his or her office. Or that might actually be the place that stresses them out the most, so find a quiet hallway or conference room. (Conference rooms seem to have improved over the years, and are less monochromatic and drab. But you may have to work harder to make this an interesting location.) For an artist, the best spot might be in his or her studio beside a favorite piece of artwork. For a family interview or scene, it might take place at their kitchen table. In good weather, consider outside locations like a garden or terrace. I can hear sound engineers groaning as I write that sentence. Of course, you will take into consideration the potential sound issues and build extra time into your schedule for this exterior shot.

Crew Meals, your Schedule and your Budget
Food is the cheapest way to keep everyone on task and happy. Try to have crew and your real-people "cast" eat together, even if it is just once during the production. The payoff is more than simple camaraderie. It makes for better footage. Your subjects will feel more comfortable with crew who are also real people, with real lives. Your crew might learn a key story that should be incorporated into the production. Also consider offering a *box lunch* as a dinner for everyone when your shoot days run long. You may not have the budget for a catered meal, but sending everyone home with a bite to eat after a 12-hour day can ensure that you'll have a good shoot the next day, or the next time you need them. *Stagger lunch.* When the cast and crew from your wide shot are wrapped, let them eat. Folks and crew that are part of close-up coverage can eat in the next meal slot. If the second lunch is significantly delayed, offer snacks to that group. These are ways to keep your schedule moving along, and all your people working together toward your story goals.

CHAPTER 2
MASTERING THE BUDGET AND SCHEDULE

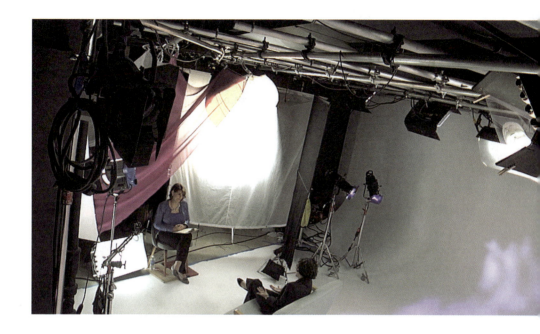

A silk can both filter light and block equipment from view.

Credit: Amy DeLouise.

Plan Simultaneous Set-Ups

On large-scale productions such as feature films, simultaneous set-ups are the norm. They're easy to accomplish with first- and second-unit teams. But with smaller crews, this option may seem out of reach. It isn't. We talked earlier about the impact of adding people to your production team. A world of opportunities opens up when you add just one grip or savvy PA to your team, who can rough in lights and move gear to your next shot location while the core team is capturing footage for the current scene. You are not just getting a step ahead of the scheduling delays that inevitably occur in production, you are creating a flow in shot acquisition that can make for a more coherent final product. Ideally, you are planning simultaneous set-up opportunities before you get on location. Yes, this does mean you'll have to bring a few extra lights, C-stands, and stingers. But I promise you it will help your schedule and budget in the final analysis. You can also bring a DSLR camera (and someone who knows how to operate it) to help grab pick-up and insert shots

or background templates for green-screen set-ups. A decent DSLR can capture an exterior establishing shot of a house where your primary team is already inside, prepping for an interview. Then the DSLR can come inside and become your secondary angle on the interview shot. Add a slider, and you've actually got a pretty nice set-up for that sequence. During particularly stressful, fast, or unpredictable scenes, having flexibility in your lighting and camera gear will give you the options you need, and prevent major budget overages.

Educate "Up"

People responsible for the bottom line—those who have hired you or to whom you report—can sometimes lack experience regarding the impact of working with real people on camera. A common misconception is that working with real people instead of professional actors will save money. "They will just play themselves" is a common response to any concerns about using non-actors. These words come from otherwise smart people, who then go to the movies and watch Bradley Cooper or Reese Witherspoon convincingly play characters who are clearly not "themselves" as they deliver a multitude of lines. It's your job to educate anyone involved in the production who may not understand how things might unfold with real people before the camera. You need to explain that scenes involving dialogue, working with props, and complex blocking—all simultaneously—are best left to paid actors. These pros will always be more efficient than real people. Sometimes they will even be more believable. Quite often, a re-enactment ends up feeling staged, especially when dialogue is involved. No matter how "real" they are, real people often cannot sell a scene in which they say and do things that they really say and do every day. By contrast, a seasoned actor will deliver a line believably every time. She will hit her mark, over and over again, in every take. An actor will tap a pencil on the desk the same number of times in every camera angle, and with every change of the lens. And be sure not to tap it when dialogue is being delivered, thus saving you money in your edit. Working in direct-to-camera situations in particular,

professionals generally get better with every take, and often don't even need a teleprompter for short amounts of copy. Real people will actually usually get worse each time they need to repeat the material, and often struggle to deal with the teleprompter. Even experienced speakers may not be consistent when faced with cameras, lights, and crew. So while they may be engaging and dynamic on camera, your subjects lack the training that brings stamina for the distance run that is life before the camera. Avoid dialogue, and excessively long shooting days, and you'll give yourself a fighting chance of letting the story emerge unscathed.

You may think I've just made the case for working with paid actors instead of real people. In certain scenarios like material for training, I do prefer paid talent for all the reasons I've outlined. But in documentary and documentary-style productions, in reality shows, and in many re-enactments (military, historical, and medical, to name a few), real subjects are essential. Embrace what they bring to the table, and plan for what they do not.

Add Cameras, Camera Angles

Adding camera angles can make your shoot and your edit more efficient and thus decrease your bottom-line costs. You're probably noticing a theme here, as I continue to insist on spending more in production to save costs in post-production. It may seem counterintuitive, but a second or even third camera will give you essential content for cutting around problem audio or actions with central characters. You can save days and even weeks of editing time or costly re-shoots. Shooting in 4K can help you achieve some of the same goals, as long as you are not delivering in 4K. In other words, you can set up shots more loosely, and crop in during post-production, but the resulting shots will no longer be full-resolution. For example, if you need to show your main character walking in the front door of a home, you can shoot your establishing shot simultaneously with your tighter framing. But wait, you're thinking,

adding cameras means adding bodies to my crew count and steps to my workflow—how can that save me money? One option when you can't afford to add two experienced DPs is to include on your team an assistant camera (AC) who is a competent shooter and can capture supplemental shots only in key scenes where he or she is not needed for primary camera support. While this can never replace the wisdom and creative instincts of a DP-operated camera, a knowledgeable AC can work wonders with a secondary angle. Another option is to mount a second camera on an auto-slider. You can set the slider to move slowly in an arc, providing you with a cutaway shot that will help solve potential jump-cuts when you are editing. Sliders are particularly useful as second cameras on interview set-ups. You will need to add 15–30 minutes of set-up time to get your slider adjusted correctly. The cost on sliders varies widely. The more sophisticated ones have more features such as the focus system, and can hold heavier cameras and lenses. They run anywhere from $110 for the smaller DSLR-mount units to $1,500 for ones

A slider can add motion to your project without breaking the budget.

Credit: Courtesy of Peter J. Nicoll.

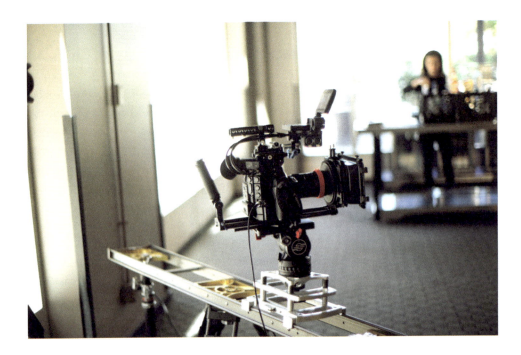

that hold heavier cameras and offer automated parabolic sliders that run back and forth—you guessed it—automatically. Consider adding a slider that can provide you with that extra content to save time and money on the post-production side of your budget.

BUILDING YOUR SCHEDULE

An ideal schedule doesn't exist in production. But a *realistic* schedule does. A realistic schedule covers your shot list and story outline while still allowing for spontaneity, creativity, and food. You also want to leave enough time to accommodate retakes and give your subject breaks. I try to plan for 20 minutes of downtime for every 40-minute block of work time when shooting with real subjects. Within that 40-minute block, we might only be rolling half the time, giving us 20 minutes of material. And that is only for each set-up, so our schedule needs to account for breaks between set-ups, or moving equipment or locations. With meal and equipment re-sets, you may get only 120 minutes of footage in a day. That can drop further if you have major company moves for multiple locations. When dealing with babies and children, try to give your schedule even more wiggle room (pun intended). In my experience, babies add significant time to every shoot day. That's why feature films and commercials book twins and even triplets as baby talent. Since you're dealing with real people, you don't have the luxury of shooting twins (unless you happen to be shooting a documentary on the topic). So remember to have plenty of alternative set-ups and back-up plans ready in any schedule with young children.

Babies on the set are not the only ones who can add extra time. Consider adding extra time if you are working with a person with a disability, who may need extra time to navigate around in a wheelchair or prosthetic device. The very frail or elderly may need breaks from appearing in front of cameras, or need extra time to get around. Often we forget that real people have real obligations to others

Sample Shoot Schedule

Time	Scene	Purpose	Notes
6:00-6:30AM	Crew arrives/unloads		Bring our own coffee and bagels for crew; put down carpet runners—no muddy shoes in the house please!!
6:30-7:30AM	Pre-light		
7:30-8:15AM	Family breakfast	B-roll, natural interactions	
8:15-8:45AM	Alexa, Matthew and Mom Busy walking to school bus	B-roll, talking about school stuff	DP and Sound only; Grip pre-lights interview shot; cannot shoot kids who aren't cleared to be in the show; get releases on site and make GREAT notes about who's out.
8:15-8:45AM	Grip pre-lights interview set-up in family room		
8:45-9:15AM	Mom does her hair/makeup; powder her for camera with our own kit		
9:15-10:00AM	Interview Mom	Get her to discuss things that will be coming up in the day—the important meeting, the kids' activities	Use auto-slider for 2nd camera angle
10:00-11:00AM	Give Mom a break from camera; she changes clothes for lunch meeting	Crew moves gear for lunchtime meeting setup	
10:30-11:00AM	Crew presets lunch meeting scene		
11:00AM-12:00PM	Crew lunch		
12:00-12:30PM	Mom setting up her lunch meeting—puts out agendas, etc.	B-roll, chatting direct to camera about the meeting	
12:30-2:00PM	Mom runs lunchtime meeting		Get releases from meeting participants!
2:00-3:00PM	DP gets a house exterior while crew wraps out of home		
3:00-3:30PM	Driving shot—interior of car, Mom picks up kids, drops Alexa at piano, then Matthew to soccer practice	B-roll, chatting with the kids	OPTION—if Mom doesn't want crew in car, crew gets shot of car leaving, then drives ahead and meets them at soccer for final shots
4:00PM	Wrap crew		

Sample shoot schedule for busy family that gets five b-roll scenes, an establishing shot, and a two-camera interview in one day.

Credit: Amy DeLouise.

during the shoot day. A father might have a sick child who needs to be picked up at school. Or he might need to leave the set to attend a meeting or take a telephone call. These are all distractions that not only take time away from the shoot, but break the flow and continuity of creative thinking for you and your production team. Plan for this, and have either more time scheduled overall or additional shots that can be easily acquired during unscheduled breaks. And finally, there's another category of person on the set who will add extra time to your schedule: an executive producer (EP). I typically add 10 percent overage in time for each EP or other supervisory person on set. Insert production joke here. But seriously, folks who have not been involved with the day-to-day planning of your interview, reality sequence, or re-enactment, may have questions or input that slow down set-up time or even stop the action entirely. Be prepared in advance. Having a separate, large monitor away from your own director's monitor is helpful for making clients, executives in charge, and handlers feel welcome, while keeping them out of your way. On page 40 is an example of a schedule with alternatives blocked in for real-people variables.

B-Roll Planning and Your Budget

B-roll doesn't just "happen," especially if you are shooting on a particularly tight timetable. My rule of thumb is to shoot three to four scenes of supporting material for every 5 finished minutes of story. This generally works out to a day of shooting b-roll for every day of shooting interviews. Too many productions expect their DPs to gather this vital footage during official breaks or lunch. Everyone needs to recharge, especially your camera person, so *scheduling* your b-roll scenes will make your entire team happier. In addition, on-camera subject(s) also need breaks. So to expect that immediately after wrapping an interview, someone will want you and your camera following them around to get b-roll may be unrealistic and stress-inducing. Build your budget and schedule so that you give your subject time to decompress—perhaps while the team is picking

up an establishing shot that doesn't require them in it. Plan key scenes well in advance: "We'd like to get Sarah hanging out with her school friends—can you invite them all to come to the house at 4PM on the day of our shoot?" And try to work around existing opportunities: "Since you told us you have full office team meetings every Monday at 11AM, can we be a fly on the wall this Monday? And can we get into the room a little in advance to put up a few lights?"

BIDDING

One of the most difficult parts of production is anticipating costs for bidding purposes. If you pitched your documentary subject to a network, for example, you may have provided a budget range, but still be required to provide final pricing. If you are responding to a Request for Proposal (RFP) for your project, you will need to "bid" on the budget too. The Association of Independent Commercial Producers (AICP) has created guidelines for ways to bid and invoice. Whether or not you are producing a "commercial" production, these guidelines make a lot of sense, at least as a starting point for your own process.

Fixed-Price or Cost-Plus Budgeting?

Two common types of budget are fixed-price and cost-plus. Then there is often a third, hybrid budget, which combines elements of both. In the cost-plus scenario, which in many ways is the simplest to develop, you itemize all the anticipated expenses and add your above-the-line day rate or project rate to this amount. When billing time comes, you invoice for actual costs, with any mark-up or management fee agreed upon, plus your own fees. Seems simple, right? Well, not always. The biggest problems with cost-plus budgets are:

1. Failing to anticipate significant costs and cost drivers, leading to after-the-fact negotiations on pricing; and

Budgeting for Wearing All Hats

It's all fine and good to talk about adding crew when you have a crew, but what if you are the director, producer, shooter, audio person, and editor? My hat is off to you, first of all. But there are some things you can do to minimize surprises when working with non-professionals. Conducting a location scout becomes of greater importance to minimize time delays while shooting. Use all the digital tools at your disposal—Google Maps, etc.—to augment your scout and turn up any variables that could affect your timing. Your rapport with the subject in advance of the shoot also becomes a priority, since you won't have any other folks to run interference for you. I'd still recommend adding a PA to your field team. The cost impact is minimal up front, and the benefits of having an extra pair of hands, and better script notes, will save you time in post-production.

2. Failing to anticipate the length of time needed for completion of the project, leading to added overhead costs that some party will have to absorb (and you don't want it to be you!).

When working with real people, many of the scheduling impacts come on the front end, trying to coordinate schedules for them to appear on camera. But there can also be more time needed on the post-production side, for editing soundbites and resolving any continuity of action issues with b-roll.

Putting together day rates shouldn't pose a major challenge. There are usually standard rates for every region. Even if your shoot is non-union, a good place to start for lighting, electric, and grip department rates is the International Alliance of Theatrical Stage Employees (IATSE), the union for most positions in the motion-picture industry. Local 600 is the IATSE guild for cinematographers, and can provide standard rates in this category. If you know up front that your day will run longer than 8 hours—and what shoot doesn't, really?—then negotiate a longer day up front. Waiting until the clock goes past 10 hours is not the time to negotiate! Generally, I have my teams on a 10-hour day if we have multiple interviews and b-roll set-ups with real people. It's just the reality of working with non-actors, and gives us the time to cover the story in the way it will be most compelling.

Let's talk for a moment about overhead costs. Many creative businesses underestimate this expense—a percentage on top of all productions that covers your rent, utilities, taxes, maintenance, and administrative costs that support all projects. Unless you have built an overhead expense percentage into your contract and can bill this for every week or month of the project, including when it goes past the specified schedule because of variables you don't control, then you face losing considerable money when schedules change. And through some law of the production universe, schedules almost always change. By putting both a realistic schedule and an overhead rate into your budget, and by identifying up front those factors which might lead to time-related cost increases, you will have both

some financial security and some concrete reference points for your contract for the project.

Production Contracts

You should always consult an attorney who is familiar with television and video production when developing contracts. But sometimes it's useful to look at other industries for guidance. Architectural contracts are very protective of the entity doing the building, and may have some useful clauses to emulate in a production budget. You can purchase samples at www.aia.org/contractdocs/index.htm. Why would I recommend looking to architects for a contract model? Because the workflows, reliance on subcontractors, and variables such as weather in both of these industries have quite a bit in common. Both construction and production require defined workflows, and teams of specialized subcontractors. Both construction and production can be weather-dependent. And both industries also involve a creative design phase, a planning phase, and a "putting it all together" phase. Some video productions are what I'd call "design-build," meaning that the "architect" of the concept—the writer/producer—is also the one in charge of executing the concept through production. Others have the design concept created by one individual (or group) who then hires a production team to execute the vision. Some productions are cost-plus, and others are done for a fixed fee, but with the stipulation of specific equipment and schedules, much like a construction agreement. One way you can clarify how certain decisions and timing affect others is by building what I call a dependency schedule. This schedule does not include dates, but rather "Week One, Week Two," and specifies the turnaround times *between* various deliverables when one is dependent on the approvals involved with another. So, for example, if your second draft script can be turned around 3 days after you receive notes, you would list this deliverable as "3 business days after receipt of notes." Note the use of "business days." For some reason, notes always come on a Friday afternoon and EPs always want the next draft on Sunday! If you are willing and able to

CHAPTER 2
MASTERING THE BUDGET AND SCHEDULE

Sample "Dependency" Schedule

Week of	What	Dependent On.../Budget Implications
July 6	Finalize Storyboards and Creative Concept	
July 13	Proposed Subjects—at least 10 possible people of different ethnicities and ages	
July 20	Finalize casting—5 people plus a large group of extras for a re-enactment scene	
July 27	Shoot Subject interviews and b-roll—subjects 1, 2 and 3; make personal photo requests or acquire on shoot	Some subjects' vacation schedules may impact shoot dates; overflow into week of August 3rd or 10th at latest; no budget impact
August 3	Shoot Subject interviews and b-roll—subjects 4 and 5; make personal photo requests or acquire on shoot	
August 10	Re-enactment Shoot with large group; back-up shoot date for any interview subjects not previously available	Exterior shoot—Weather-dependent—budget impact if late cancellation
	Review Interview Transcripts—find best bites	Transcripts to be completed within 4 business days of interview shoot completion
August 17	Begin photoshop/resizing of subject's own photos	Photo prep to be completed within 3 business days of receipt of subject's photos
	Paper script based on interviews	Script to be completed within 4 business days of receipt of all interview transcripts
	Re-enactment shoot rain date	Rain date may add a weather "kill fee" of 10% crew and equipment costs, depending on how late we can call it
	Begin editing re-enactment footage if no rain delay	
August 24	Editing of re-enactment footage if rain-delay occurs; Editing of interviews	
August 31	Integrate re-enactment footage into interview stringout	
September 7	Rough Cut reviews; Lower thirds and opening title sent for review	
September 14	Fine cutting	Fine Cut to be completed within 5 business days of receiving all feedback on Rough Cut including approvals/changes to lower thirds and opening title sequence; late approvals on LTs/Title may affect graphics budget
September 21	Fine Cut reviews; all on-screen lower thirds and opening title sequence must be reviewed and approved	Final draft to be completed within 3 business days of receiving all feedback on Fine Cut
September 28	Picture Lock Approval; Audio Mix	Audio mixing will take place 48 hours after picture lock approval
October 5	Mixed audio layback; QC Final Show; outputs	
October 16	Final Air Date	

Sample "dependency" schedule—identify inter-dependent events in your schedule.

Credit: Amy DeLouise.

provide weekend work, that's fine, but it's important to be clear in case there are budgetary implications.

Fixed-Price Budgeting

In fixed-price budgeting, you are establishing a "not to exceed" amount for which you can do the production. Many corporate and non-profit productions use this model, because they can put in for a specific line-item cost in their marketing or outreach budgets. In this budget scenario, there are incentives built in for you to keep costs down, so that you can increase your margins. The problem with that is that the same variables and unknowns exist as with cost-plus contracts; these can throw off your schedule or content plans. Typically, I work under fixed-price budgets for projects where the end-user is an entity I have previously worked with many times before. I have an understanding of their internal approvals process, of the people involved, the production variables I need to account for, and the creative elements they are most likely going to want in a final product. The same dependency schedule can be used for a fixed-price budget, and can help you inform all the parties in advance of delays that will affect the final budget.

Hybrid Budgets

Sometimes one format or another just doesn't work for a budget, and you have to improvise. Extensive travel variables can make it hard to do fixed-price budgets, but often the broadcaster or executive producer needs *some* idea of how much those variables will be. Unknown interview subjects at the start of a documentary production can also make it hard to deliver a definitive budget. These subjects may be emerging in the research phase, and they may live in different parts of the United States or the world, affecting the hiring of crews, the workflow for editing, the need for translations, and more. This is when the hybrid budget comes into play. Some components can be

CHAPTER 2
MASTERING THE BUDGET AND SCHEDULE

fixed; for example, research fees, scripting and revisions, and the number of rough cuts and fine cuts delivered. But perhaps production variables are just too great at the outset, so these are estimated in a cost-plus format. The final budget will have ranges, rather than a fixed number. Keeping track of all these different formats can be challenging, so this is when we turn to technology to lend a hand.

Digital Tools

A Movie Magic scene breakdown sheet and stripboard.

Credit: Screen shot created using Movie Magic Scheduling software owned by DISC Intellectual Properties, LLC dba Entertainment Partners.

Let's talk about apps. In our digital world, there are a myriad nifty scheduling and budgeting tools to choose from, including several production software tools that help you generate stripboards—those filmmaking tools in which a "strip" is created for every scene in a

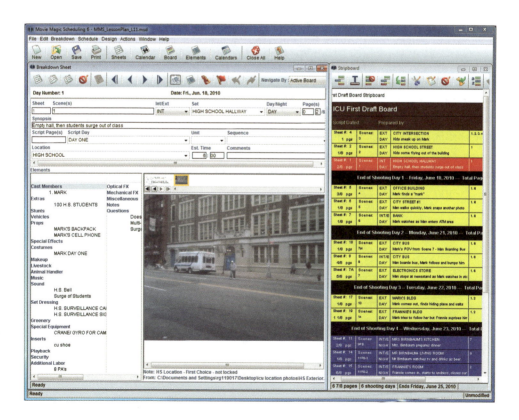

47

script, and then you can move them around to plan your shooting schedule. Several new apps, such as iStripBoard (Apple), are available to help you build your schedules and carry them onto the set in your iPad or iPhone. If you are juggling a large crew, multiple locations and scenes, and a lengthy production in screen time and/or shoot time, a more robust scheduling tool like Movie Magic Scheduling (Entertainment Partners) may be your answer. The scheduling software offers helpful tools, such as the ability to import a script to create breakdown sheets to which storyboards or other images can be attached, helping you to visualize each day's work. Data from Movie Magic Scheduling software can be reused in Movie Magic Budgeting (Entertainment Partners' budgeting software), so you don't have to retype categories or personnel for your project.

If your production is on a smaller scale, you may be able to use one of the software tools from www.junglesoftware.com—either Gorilla for larger projects, or Chimpanzee for smaller ones. ReelGrok offers a number of budgeting tools and templates on their website (www.reelgrok.com), including resources specific to genres such as reality TV. Or you can build your own budgets and schedules using templates in plain old Microsoft Excel, which is a robust and fully customizable tool. Whatever works for you and gives you the most flexibility to manage variables is the right program for your production.

CHAPTER 3

LOCATIONS

Andy Collins

SETTINGS ARE CHARACTERS IN your story. A location can evoke a particular emotion, frame a theme, and provide context for central characters. Just a few quick establishing shots in a location can make all the difference in defining the tone for a coming scene or interview. Sound also plays a crucial role in a story. I've shot in urban environments when the streetscape visual and audio play a critical role in establishing the characters on screen. Recently I was shooting an exterior sequence on a cold, rainy day in Chicago. Establishing the main character walking on a busy street, with Chicago's iconic elevated subway rumbling overhead, was an essential opening sequence before we saw the subject in the on-screen interview. For a documentary project in Appalachia, we were able to create a snapshot of the setting with shot sequences of the mist drifting down the hills, and trucks driving through long-boarded-up main streets. We used long lens shots in several locations we had scouted, in order to introduce the main characters in the film— a group of energetic, elderly Catholic sisters doing grassroots-level social work, intrepidly driving their older-model cars on the winding roads of Western Kentucky. When faced with production timetables and budget restraints, it's hard not to view locations as obstacles to be overcome—a room that's too noisy, a building without ramp access for gear, a crime-ridden neighborhood where you will need to post security by the grip truck. But while you are solving problems, try to see marvelous opportunities to enhance story lines, and build critical context for real people on camera.

LOCATION SCOUTING

Location scouting for feature film and commercial productions has become something of a lost art. Larger productions still rely on professional location scouts. But many smaller productions forego what they perceive to be an unnecessary expense. When shooting out of town, do consider adding a location scout to your team, if only for a day or two. She can save you thousands of dollars in production time by sharing critical information about crew parking,

one-way streets, traffic patterns, building entrances, places to eat, and places to stay. When location scouting, take these issues into consideration:

1. *Opportunities.* What does the location contribute to the story? How does the scene play a role, act as a character, or help to quickly define the mood or theme of a show?
2. *Risks.* Are there unique risks to using this location? Are there physical risks to crew members? Are there availability risks, meaning that it might not be usable during certain times of the day? Are there other ways to replicate this location in a safer or more available setting?
3. *Sound.* What sounds need to be captured as part of the setting? What is the best time of day for sound at this location? What is the worst time for getting good audio? Are there nearby fire stations or airports that might cause repeated sound problems? If the answer is yes, make a note on the schedule to include several points for acquiring "room tone" throughout the day. This won't cost you a dime, but it will save you loads of aggravation in post-production, because a sound can only be notch-filtered out if you have a sample of the sound by itself, not mixed with dialogue.
4. *Images.* What visuals need to be captured here? Can we shoot test shots? What are the optimal times of day for natural daylight on the day we are shooting? When is dusk? Are there special visual considerations, such as streets that need to be cleared of parked cars or pedestrian areas where you may have to direct people around equipment? Do you need special access to the best camera angles, such as shots from rooftops or balconies?
5. *Logistics.* Where can you load in gear? Where can crew park? Where can gear be stored? What about staging—is there an out-of-the-way area where gear can be easily accessed?

6. *Gear.* Is there any specific gear you need to optimize this shoot location? Perhaps a mini-jib? A Dana dolly? A Steadicam™? HMIs?
7. *Crew.* Does this location require specific crew? For example, an extra PA to shuttle cars to off-site parking? Or an extra grip to help manage challenging lighting set-ups?
8. *Travel.* How do you get there? How far is it from other locations you need? Have you budgeted for fuel costs? Will it make more sense for crew to be housed closer to the start location or the end location?
9. *Legal.* What location agreements and insurance certificates are required? Are there any other rights considerations for this location (i.e., a copyrighted sculpture in front of a building where you are shooting a key exterior)? Are there stock agreements that can be used, or do I need to hire an attorney to help me with the issues?

If you can't scout, take advantage of the many online and digital tools that are available to help you narrow the many variables of location production so you can make better decisions in advance of arrival. You can use the websites of the locations where you are shooting. Try tourism offices for major cities—they often have large photo and video libraries you can access for an advance look at your prospective locations and iconic scenes. Flickr (www.flickr.com) is an excellent resource for images of locations all around the world. It's worth noting that you shouldn't be trolling Flickr or other sites for images to put into your show unless you are pursuing permissions for them. Google Maps Street View (www.google.com/maps/streetview) can help you find critical information, such as the availability of parking or the configuration of doorways that could create issues for loading equipment. Foursquare (https://foursquare.com) gives you mission-critical intelligence on nearby eateries or parking garages for your crew. For regions of the world where Google may not have driven their camera cars, try OpenStreetMap (www.

openstreetmap.org). This community-sourced wiki (user-editable website) provides unusual detail about locales, including overlays such as "humanitarian." Need to plan a shot during the next full moon? Or shoot a scene at "magic hour"? No problem. The LightTrac app (www.lighttracapp.com) works for iPhones and iPads as well as Androids. It can plot the angle of the sun or moon on a particular day and time on top of a map for your prospective location. You can save multiple locations and toggle between them as you plan your shooting schedule. Photopills (www.photopills.com) is a newer light-planning app, and at the time of this book going to press was not yet available for Android. Its algorithms can plot your shot in relationship to the sun, the moon, or various constellations and stars. Whether you use technology or do physical scouts, or combine the two, advance location planning is not just useful for exteriors, but for planning when light will be coming in through interior windows, creating challenging back-lighting situations for scenes or interviews.

CHALLENGING LOCATIONS AND SOLUTIONS

Sometimes you need a key location, but know in advance that it will create scheduling challenges. Minimizing these can be the difference between a productive shoot day and wanting to find a new career. These are among the most challenging locations:

- **Hospitals**
- **Schools**
- **Military environments**
- **Live events**
- **Hollywood studios**
- **Noisy offices**
- **Locations for investigative stories**

Schools and Hospitals

There are some ways to minimize the risks of using these locations. In hospitals, develop multiple schedules to give you options when you find your location or your essential personnel are called away for an emergency. Minimizing the size of equipment in this set-up can also help speed up load-in and load-out, so you have more time for shooting. Make sure that hospital public relations or media relations staff is part of your team, and well aware of your goals in advance of the shoot day. They will help minimize violations of the Health Insurance Portability and Accountability Act (HIPAA) by ensuring you get approvals—preferably in advance—from any patients who are participants on camera. In schools, you will come up against similar issues around not being able to film minors without the sign-off of parents. Luckily, many schools have adopted an "opt-out" policy, so that at the start of every year, they have essentially got a list of children who are approved to be on camera for certain reasons, such as the school's own fundraising, website, or promotions. You may still need to plan for working around those children who cannot appear on camera. Some may be able to sit with their backs to the camera. Others may need to be taken out of the room altogether. The worst-case scenario is that you will have to keep track of who should not be included, and have their faces blurred out in post-production. Take a quick photo with your phone of any "Do Not Include" children, and email it to your editor along with shoot day notes.

Military Scenes

In military environments, there are positives and negatives to the many rules and chain of command. All footage being taken on a military base or location will require the approval of the press office. Do your homework in advance, recommends Nutan Chada (interview, September 24, 2015), a producer for the Defense Logistics Agency who travels the world uncovering behind-the-scenes stories. Despite the fact that she works for the US Department of Defense

(DoD), Chada must still get permissions for every shot. Some of her recommendations include:

1. If your crew are contractors without DoD identification, find out what kind of IDs they need to bring.
2. Find out if you need to be issued with a "camera pass." Often a letter of permission is not enough, and you need this separate pass to bring camera equipment on base.
3. Each branch of the military may have different rules for what can be filmed, and how people need to be identified on screen.
4. Be aware that military personnel are required to wear "cover"—their hat—any time they are outside. This can make seeing faces in outdoor interviews a challenge.
5. You will probably have a "minder" follow you and your crew everywhere. Be sensitive to what they need you to do.
6. Learn about ranks. If you aren't sure, call someone "Sir" or "Ma'am," and it will go a long way in your relationship-building.
7. Be willing to share raw footage—if you're getting a cool shot, it might be helpful to the public affairs office too.

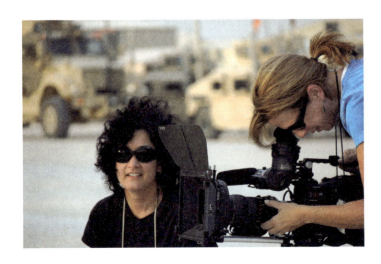

Producer Nutan Chada and DP Sheila Smith on location in Kuwait.

Credit: Nutan Chada.

Getting a shot of Marines spy-rigging takes advance location logistical work.

Credit: Courtesy of Nutan Chada and the Defense Logistics Agency.

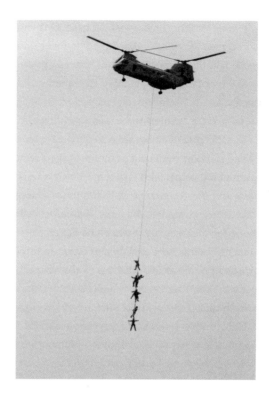

Chada says that even in dramatic military locations, the stories don't just unfold: "I make my own opportunities." For one project, she wanted to show a certain type of military-grade rope in use. Rather than show someone pulling it off a supply shelf, she negotiated to shoot "spy-rigging," in which Marines hold onto the rope dangling beneath a helicopter. The shot was challenging logistically, but worth the months of negotiations when she finally got it.

Investigative Stories

Stories that may reveal uncomfortable facts can present unique location challenges. Writer/Producer/Director Pauline Steinhorn (interview, September 26, 2015) encountered various forms of intimidation as she scouted locations for her documentary on hydraulic

fracturing, also known as "fracking." Her goal in producing the Maryland Public Television film *Fracking: Weighing the Risks* was to present both the risks and the benefits of the practice. She was careful to plan interviews on both sides of the story. But when scouting for shots, she found herself constantly being warned off by utility company personnel who always seemed to be one step ahead of her. In one instance, Steinhorn and her crew were told to leave while standing on a public sidewalk. In another case, they were on a private farm with the permission of the owner. Not only was getting a good location for filming the drilling rigs a challenge, the obstruction posed another issue: As a storyteller, Steinhorn was faced with a decision about whether to include the location stand-offs in the film. "I agonized about it. Is the story about these people trying to prevent me from getting the story? Or is it presenting the facts to the audience in Maryland, whose elected representatives would be voting soon about fracking?" Steinhorn recalls. "Ultimately I decided that my goal was presenting both sides of this story, and everything else was a distraction." Having as a touchstone your greater storytelling purpose can help determine the lengths you go to for a particular shot.

Settings are essential story characters as in this documentary on fracking.

Credit: Courtesy of Pauline Steinhorn and Maryland Public Television.

Live Events

Disaster preparedness scenes are some of the hardest to shoot. Since 9/11, there are more and more situations in which media-makers are involved in producing footage of these events, whether for documentation, training, or advocacy. I produced a multi-camera shoot of a school district disaster-planning event, and the variables I didn't control were only slightly less complex than in a real disaster environment. Picture this scene on the day of the event, which was staged at an elementary school: local police and fire department personnel and their vehicles; local Red Cross volunteers managing a triage area and evacuation center; local news teams with all their satellite trucks; and a posse of parents, as well as all of the teachers, staff, and students from the school, and each playing their appointed roles. Plus one documentary crew. Oh boy, was that a challenge! While we were included in some of the final planning stages—which we also shot for the piece—we were not really controlling any of the variables. We did ultimately offer to help with victims' stage makeup and the fake explosion, so that these would look better for camera. On the day of the shoot, we effectively had to roll multiple cameras simultaneously, with very few opportunities for retakes. Some parents became so overwrought playing their parts, as they frantically searched for children, that they became truly panicked. The footage looked great, but the scene was a little unpredictable for our crew. Every second of our careful planning counted. We had walked the scene—interiors and exteriors—many times. We had diagrams and shot angles mapped out. We knew our key characters. And we had planned for shot options, too. Insert shots of "wounded" children being triaged and school staff being interviewed by media served us well when it came time to edit, and they will for you too.

CASE STUDIES

Case Study: Planning for a Field Interview

The settings you choose for interviews and scenes play a role in your film. Whether you are producing a reality show, a documentary, or an advocacy testimonial for a non-profit organization, the settings you choose for interviews and scenes will affect your viewers and their emotional connection to your story. Perhaps this is why I am so opposed to green-screen whenever it can be avoided. For interviews, my favorite locations are ones that can provide visual depth of field. When I can shoot with prime lenses, I can make this background go soft or less soft, as the DP and I choose, so it can be more or less present as a character in the scene. But as reality image-makers, we are often working under tighter budgets than our narrative film colleagues. Sometimes we even have to make one location work for a multitude of scenes or interviews. For a documentary about teen alcohol abuse with a tight budget, I had to do just that—bring all the teenagers to one location for interviews. Yet I wanted each background to feel distinctive and right for that person. The backdrops were also intended to give viewers cues that these kids were "cast against type"—meaning that we were challenging viewer assumptions about who was a "good kid" and who was a "bad kid." On the practical side of things, we needed power and parking for the crew, and bathrooms for everyone. We located a school that had an old, one-room schoolhouse type of look: red brick on the outside, aging classrooms on the inside. For an interview with one young guy who grew up in a tough neighborhood, but overcame the odds thanks to close family ties, we chose the backdrop of a long uninterrupted brick alleyway. The brick felt like building blocks of his life. It also invoked his urban upbringing. The vanishing point in the distance felt like his future, a topic on which he was very focused throughout his pre-interview and in the live shoot. For another interview in the same documentary, we talked to two friends: a young girl who sneaks out of her house all the time to go to bars, and a boy who likes to get

CHAPTER 3
LOCATIONS

so drunk he passes out. We shot them seated on some side-steps of the school that looked like they could have been the front steps of a home. By having them seated, their casual and slightly combative vibe came through, and the interview conveyed a different energy level from that of the boy standing by the wall. I interviewed a third teen inside the building, seated on top of a desk, where we could see some of the blackboard and classroom paraphernalia. I conducted a final interview with two teenagers who admittedly enjoyed getting drunk and making trouble together. We sat them on the hood of a car (one of ours, of course). They naturally crossed their arms and made jokes back and forth during the interview. It was a perfect setting for them to talk about their relationship with alcohol.

Even when faced with location restrictions, getting creative within the environment can have a profound effect on your story. During the height of the Ebola crisis, I was asked to direct an interview with Dr. Roseda Marshall, President of the Liberia College of Physicians and Surgeons, while she was briefly in Washington, DC, meeting with fellow medical experts before returning to Monrovia, Liberia.

We interviewed Dr. Roseda Marshall in a warm, home-like setting for the PSA series *Combating Ebola*.

Credit: Courtesy of InterChange Media.

61

Knowing that the goal of the video series was to explain the risks and prevention measures to family members living in Europe and other regions, who would help to communicate this vital information to family at home in Liberia, I felt that a clinical setting wasn't the right approach. Given our short time frame, I was able to make some calls and come up with a more home-like setting in a nearby, but currently empty, pastor's office. We asked Dr. Marshall to bring some medical texts she had with her, to place on the built-in wooden shelves. The warmer look and feel created the right setting in which to discuss such a difficult topic with families who were already skeptical about the medical community.

Case Study: Planning for a Studio Location

For a social impact video project, I was asked to work in a studio setting. The non-profit organization involved was planning to bring several philanthropists to one major city to talk about what made them passionate about giving. They also needed a studio that would suit both our video shoot and a photo shoot with our principals. This was a tall order. I wanted a friendly environment where emotional conversations would feel natural. I also wanted convenience for travel, plus a place where our subjects could enjoy themselves, and have ample space for making phone calls or having conversations with one another between interviews. My shoot needed a certain throw distance behind the seating area for the lighting design I had in mind. And we needed the right space for the photography shoot with its many props and backdrops. I scouted multiple locations. Many I loved for the photo shoot, but they would have been a nightmare for video sound. Others were perfect for our production teams, but terrible for the kind of intimate conversations we wanted to create on camera. One such space was a large warehouse, which had just wrapped on shooting a heavy-metal reality show when we arrived for our scout. As the all-black-clad rockers filed out, I peeked into the central studio with its impressive scissor lifts for lighting. The space was just too vast, and too production-oriented

to make our guests feel at home. The space I ultimately chose was a much smaller studio venue. While the size of the shooting stage itself created some production compromises, the location offered a cozy living-room-type space adjacent to the wardrobe and makeup rooms, with a monitor that could deliver a live feed from the studio. This delivered the right environment where our "cast" could feel comfortable and engaged in the topic at hand, rather than under the spotlight in an alien environment.

LOCATION AGREEMENTS

Location agreements are a necessity of life in production. I started my career working as a location PA for feature films, commercials, and documentaries—what I affectionately call the "permits and porta-potties" segment of my career. But I still have to handle these for my own, albeit smaller, productions. There are five key things you have to think about for locations when working out your agreement with the property owner:

1. What is the end use of the project—where will it air? And where might it end up after that—a.k.a., the internet?

2. Where will your cast and crew be parking; loading in; staging equipment, props, and sets; plugging things in; eating, and going to the bathroom?

3. How long do you need to be at the location? Are there circumstances under which you might need to come back on another day or extend your stay?

4. What is the fee, if any, for using the property?

5. Who is indemnifying whom regarding any damages, and what insurance applies?

Most networks and production companies will already have developed their own versions of location agreements. You can, of course, find plenty more online. If this is your first time needing one, it makes sense to use an attorney to be sure you are properly covered. The American Society of Media Photographers offers excellent resources for a variety of agreements on their website (www.asmp.org).

TALENT RELEASES

Just as with a release for shooting on a location, you will want an attorney to help you create a release for any "talent" appearing on camera, even if they are what we are calling "real people" in this book. For interviews, you can create a simple release form which indicates that the person is not being paid, and is willing to appear in your production. As in the location agreement, you'll need to identify where your production will be seen. Attorneys like to add clauses for "any and all media" and "in perpetuity." The reason these blanket clauses are important is because they protect you from having to keep track of all the end uses of your production and having to get new releases from talent if your production gets a new life. Lots of shows end up being re-cut for a "Best of" series. Others end up on the internet. Often these new uses might happen after you've moved on to another project. So the easiest thing to have is one of those blanket clauses so you don't have to keep track of which releases do or don't allow some usage. Many networks won't even allow someone to appear without signing such a clause. But often you will discover that these blanket releases make people nervous. They have a point! Don't be averse to having a subject cross out or revise a usage, if it makes them more comfortable, and you can live with it and keep track of it for the long run. A pediatric hospital I work with will only ask parents to sign a 3-year release for images of their child. This is understandable, since some of these children are very sick, and it could be incredibly upsetting for a parent to see a deceased child on screen years later. And even with such a release

CHAPTER 3
LOCATIONS

Filling out talent releases gives you an opportunity to interact before taping.

Credit: Photo by Wendy Faunce.

being current, we make sure to review every image of every child with the in-house team who are familiar with all the patients before using them in a production. Here again, you can turn to ASMP for handy release samples on their website (https://asmp.org/tutorials/property-and-model-releases.html).

WHEN YOU HAVE NO CHOICE OF SETTINGS

What about settings where neither you nor the subject have a choice? I shot a scene in a prison where my crew and I had just one option for a place to set up our equipment for the scene. But even then, I was able to work with my two subjects prior to shooting to discuss the placement of the camera, and give the inmate a

65

small sense of control about the scene. This made him slightly more comfortable, and able to be more natural during the scene. "What about green-screen?" you will ask. Suffice it to say there are not many people in this world, not even experienced professionals, who feel truly at home surrounded by green. Sometimes I must conduct interviews in a studio setting. In this case, scouting the best studio environment takes on two dimensions: what I need to make the shots work technically; and what I need to make the subjects as comfortable as possible in an unnatural setting.

OTHER RIGHTS TO CONSIDER ON LOCATION

Just when you thought you were safe with your talent and location releases in hand, you've got one more set of rights issues to consider before shooting with real people. There could be copyrighted artwork, sculptures, and architecture in the background of your shots. In certain cases, these may be covered by fair use, depending on the type of production you are shooting. In other instances, such objects may require separate clearances, and it is well worth money and time checking with an attorney. Many attorneys working in this area, by the way, will agree to a flat fee for some basic clearance work, as long as you are very detailed up front about which artwork or visual you want to clear, for what period of time, and for what distribution outlets. Check with your local chapter of the Television, Internet & Video Association (TIVA) or Women in Film & Video for recommendations. One of my colleagues represents the artist who sculpted the three soldiers' statue in front of the Vietnam Veterans Memorial, where many people like to shoot. Even though the memorial itself is on National Park Service property, and you would go to them for the location release, they will clearly inform you that you cannot include this statue in your footage without a separate release from the sculptor's estate (he passed away some years ago). This was the same sculptor who sued Warner Bros. Studios for adapting his *Ex Nihilo* frieze on the front of the Washington

National Cathedral without permission for the 1997 film *The Devil's Advocate*. I'm guessing you don't have the legal budget of a major Hollywood studio, so it's always good to check in advance before you shoot. For more details about fair use for documentarians, you can access the excellent *Documentary Filmmakers' Statement of Best Practices in Fair Use*, put together by the American University School of Communication's Center for Media & Social Impact (www.cmsimpact.org/sites/default/files/fair_use_final.pdf). Alright, we've dispensed with many of the logistical aspects of planning your production. Now let's talk about what you really love: the story.

CHAPTER 4

PLANNING YOUR STORY

Andy Collins

SOME PROJECTS DEMAND YOU map out your story elements well in advance. You may want to write a detailed outline or even a "fantasy script," mapping out some potential soundbites if your show is interview-driven. Other projects require a more flexible approach, with potential scenes and characters evolving as you shoot. Regardless, you'll need to think through the arc of the story. At a minimum, I like to draw my story arc on a piece of paper or tablet and map out the key elements visually. This is something I can share with my crew. It's especially important if I have multiple crews in several locations, so everyone is literally on the same page, and knows which scenes, sound, and characters are the most critical to the story.

GRABBING YOUR AUDIENCE

As soon as I walked onto the set, I knew something was terribly wrong. That's a hook. And it should happen somewhere close to the beginning of your piece. It's the reason viewers stay tuned. For long-form documentary, your hook might be part of the on-air promos for the film.

Tonight, from director Ken Burns . . . The monumental saga of an exceptional American family whose impact is still felt across the nation . . . The drama of it is unmatched in our history . . . Theodore, the once-sickly boy who stormed into Washington

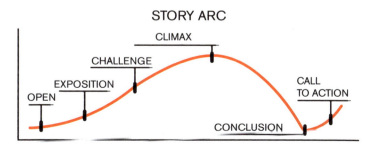

Story arc drawing.
Credit: Amy DeLouise/Andy Collins.

69

> **as if he was charging into battle . . . For the first time, peer into the private lives of the most public of people . . . Theodore, Eleanor, Franklin. The Roosevelts: An Intimate History, next on PBS.**
> (*The Roosevelts*; premiered September 14, 2014)

That's several different hooks: one for people who want to watch anything from Ken Burns, one that plays up the epic nature of the family, one that takes a more personal angle on Roosevelt's life, and one that appeals to our interest in the lives of the rich and famous.

If your video is short form and primarily viewed online, grabbing the audience more quickly is essential. For my productions, I try to use a hook that is connected to the main challenge or climax of the piece. It contains some element of the central conflict. My hook won't reveal the whole story, of course, but gives the viewer just enough of a taste that they have a "way in" to the content or central theme. Here's an example: "Unlikely rock 'n' roll photographer, Jini Dellaccio, visualised punk before it had a name, captured grunge before the hype, embodied indie before it was cool." That's the premise and the hook for *Her Aim Is True*, a documentary by Karen Whitehead (2013) about the rock photographer who changed visual history for this musical genre. Whatever your hook, and whether it is narrated or first-person, or a quick segment before your full re-enactment begins, a strong hook entices the audience into engaging with your real-people characters and their story.

THE EXPOSITION

In drama or non-fiction, primary characters must be introduced. During this exposition, you can also fill in any back-story that the audience needs to find their way. Since I work in short form, sometimes my expositions might only last 30–60 seconds. The exposition

could be a soundbite from the main character, describing herself. Or it could be footage introducing the main character, but with a narrator's voice-over. Or it might be one of the "validator" characters in voice-over, telling us something essential about the protagonist. In one of my all-time favorite short documentaries, *Cain's Arcade*, the hook lasts about 30 seconds, with Cain telling you who he is and that he built an arcade. His father is the validator, and in the hook we hear his voice over footage of Cain playing. The father explains how Cain likes to take his toys apart, how he loves playing games, and that it was natural for him to build his own arcade. The exposition comes immediately, with the father explaining further how Cain came to build this complex arcade from cardboard boxes. "Cain spent summer vacation with me. We sell auto parts in East LA." "My dad has lots of boxes, so I cut 'em up. The first game I made . . ." You just can't help yourself. You want to know more about how this nine-year-old boy came to build such an elaborate arcade. Both the hook and the exposition are largely done through interviews as voice-over, with the visuals providing rich information about the magical world of Cain's cardboard arcade. In this 11-minute documentary short, the hook and exposition happen fast. In long form, they can obviously unfold over more time. But for suspense, you may still want to save certain "reveals" for later in the story line. And whether you are working in long-form or short-form documentary, the exposition must be accomplished without making the viewer feel bludgeoned with dull facts. Ideally, the visual information is equally if not more compelling than any audio describing your primary characters, so try to map that out first.

Other components of an effective exposition include establishing shots of locations to help evoke the circumstances or environment in which your characters live and breathe: a gritty urban street scene, a poverty-stricken rural area, the busy waiting room of an emergency room, the buzzing excitement of children coming off a school bus. When you set the stage in this way, you bring emotional content to the story and context for your real-world subjects.

THE CENTRAL CHALLENGE

The challenge is the reason we're all still watching. It's why we love real-people stories. We want to know what obstacles they've overcome and how they do it. If they are good guys, we'd like to see ourselves in them. If they are bad guys, we'd like to think that we'd never end up that way. Either way, the central challenge proves essential to the story. For longer-form productions, there may be multiple challenges. Yet so many non-fiction pieces are missing this essential element. Particularly in the informational and educational arena, videos seem to proceed with tedium, through a beginning, a middle, and an end. That's it. How dull. Even if you are designing an informational video for training, you can create a central challenge—otherwise why would this training be needed?

Viewers follow the journey of Crystal Liston (right), host of *Healers and Healing*, produced by InterChange Media, here with Chinese healing arts specialist Karen Joy (left).

Credit: *Courtesy of InterChange Media.*

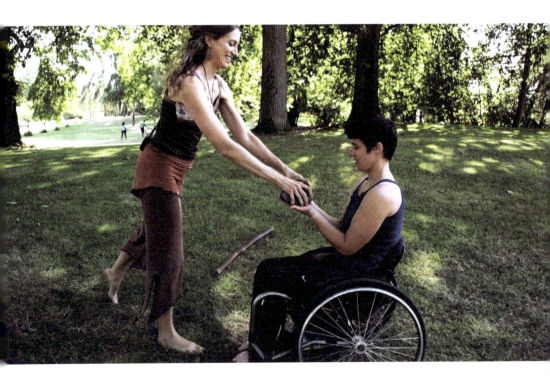

CLIMAX

The climax of a story is the turning point. Simply put, the main character finds a way through a challenge, takes some critical action, or changes her mind about an issue. If, after interviewing your potential subjects, you don't know what the climax will be, you've got a serious problem. I recently was approached about working on a program that had some interesting potential characters—someone involved in the 1960s Civil Rights Movement, and a major religious leader. The problem was, I couldn't see a central challenge or climax. The two main characters were in total agreement about the issues at hand. They were going to be filmed taking a journey together to some key religious sites around the world. The idea was to show them working together in support of civil rights and religious freedom. But even a good buddy picture has to involve some central challenge for the main duo. I declined the invitation to work on the project. Maybe I missed a great opportunity. Only time will tell.

The hallmark of a great climax is that you'd be extremely irritated if a commercial break interrupted that scene. You want to know what happens to the child with the heartbreaking disease—will he be cured? You want to know what happens when the filmmaker of *Cain's Arcade* invites his friends to come and play in the boy's usually empty arcade—will they come? Good reality television shows have mastered the art of playing up life's conflicts. These are not always massive psychological issues. It could be a rock that is too large for the team to move on *The Pool Master* (Animal Planet). How will they get it moved in time? The rain is starting to come down, how can they keep working? In an educational video, you can also reveal the drama of a conflict resolved. What did the boy do about the kid who bullied him before the anti-bullying program was instituted at his school? What obstacles did he face? Offer a point-of-view shot as he walks, terrified, to the bathroom. Will the bully still be waiting for him? Or will something change? When you build a climax into your real-people story, you are revealing the drama of real life.

But what if you are creating a series? In "scripted television" reality shows, each episode must have its own climactic moment. Lisa Feit, who was working as supervising writer/producer on National Geographic's *Diggers* series when I spoke to her, often reviews hundreds of hours of footage before she begins to refine a story. "I find the most dramatic moment of the day, and I build around that," she explains (interview, February 13, 2015). Then she works to frame the story over the course of the episode. For Lisa, finding that perfect moment is one of the joys of storytelling with real people: "There are hidden tiny nuggets that you find that make the entire show, the entire story."

CONCLUSION

In episodic reality, there may only be a cliff-hanger and no true conclusion to the story. For everyone else, there's an ending. The ending wraps up loose ends. Sometimes text on screen does the heavy lifting: "Arthur was released from prison. He is now living with his family in Iowa." Sometimes a character or narrator tells us what happened in the end. In advocacy or testimonial media, the ending may include a call to action—"I hope more people join me in supporting this clean water campaign." It's important to know what "the envelope" (as I call it) will be for the show when devising the ending. The envelope literally envelops your video, whether that is the website it will play in, the email where the link is embedded, or the large crowd who will watch it together at a live event. Where do you want people to go next? What do you want them to do with this information? Consider more than just wrapping up the loose ends of your story. At the end of *An Inconvenient Truth* (2006), the film offers opportunities for taking action, such as planting a tree or calling your congressperson. Today, embedded links on YouTube, Wistia, and Vimeo, as well as interactive TV options, provide even more opportunities for the audience to engage immediately following the conclusion, so remember that your "ending" may only be a beginning.

BUILDING A MACRO STORY WITH MULTIPLE NARRATIVES

Often, stories are part of a series, fitting within a master narrative arc. You can build such a narrative in two ways:

1. Stories that all support a main narrative premise, with each one echoing elements of the others.

2. Each story tells a different component of the full narrative arc.

Both are effective storytelling strategies. So your choice may be determined by your goals as a creator and your distribution format, as well as the strength and content of your subjects' stories.

There is something very powerful about a story in which every speaker has had some kind of shared experience, even if they don't know one another. This is the strategy of author and podcaster Jaime Tardy, the founder and host of the *Eventual Millionaire* podcast. For her series, Jaime works to find interesting, engaging millionaires who earned their money through a business idea that they launched. She interviews a new millionaire every week, and has interviewed more than 200 in the past 4 years. So what does she look for? How does she find people with distinct stories, that all fit into the "How I became a millionaire" story? Jaime says, "I try to hone in on their 'before' story, because that's what our audience can relate to. People put millionaires on a pedestal, and my job is to show they are real people . . . that they've had bumps along the way" (interview, May 14, 2015). Even though listeners (more than 80,000 downloads a month!) are tuning in to a particular story, they are also connecting to a broad story arc with a hook, a set of challenges, and resolutions: What makes successful people tick, what obstacles do they face, and how do they get beyond them?

In the second approach, where each story tells a component of the full story arc, the stories still need to have something in common.

Maybe every student who has attended this school has been touched by its unique approach to learning. Or every soldier who has come through this program has faced his or her most difficult physical and mental challenges. But rather than having each story support the overall premise, each one tells one theme in the story. Through your pre-interview and research process, you can discover the big-picture themes of your film, and then decide which character best reveals that theme. Within each theme, there can be a mini story arc with a challenge to be overcome. But the connectivity isn't revealed until the end.

SHOT LIST PLANNING

You've established your primary and secondary characters. You know your locations. And you have some idea of your story arc. Now it's time for the critical work of shot planning. For some productions, particularly long-form documentary and reality TV, you may have broader brush strokes for your shot planning. General scenes might be on the list (night time: making dinner and conversation about the day). Or you may want very specific shots for those scenes (steaks on the grill, Susan pours beers, family and friends around the campfire). The goal is saving agony in edit, and supporting a strong story. A secondary goal is giving my on-camera subjects some respite away from the lens. So I try to include shot sequences that give them some breaks. A single long day's b-roll shot list with five key scenes for a production featuring a family might look like this:

CHAPTER 4
PLANNING YOUR STORY

Build a Shooting Schedule

Time	Scene	Purpose	Details
6:45-7:00AM	Crew arrives/unloads		Put down carpet runners—no muddy shoes in the office.
7:00-8:00AM	Pre-light corporate board room		
8:00-9:00AM	1. Corporate meeting	Establish Marcus as a CEO/leader	Check for logos on soda cans, etc.
8:00-9:00AM	Lighting set-up in Marcus's office while meeting is going on		
9:00-10:00AM	2. Marcus's office	Establish Marcus as a busy CEO	
10:00-11:00AM	Crew wraps out of offices, company move to Food Bank where Marcus volunteers		Producer to do a final check to be sure we leave it clean
11:00-11:30AM	Cam 2 grabs establishing shot of office on the way out, meet team at Food Bank		
11:30AM-1:00PM	3. Food Bank	Show Marcus volunteering, packing bags of groceries	
1:15-2:00PM	Crew lunch		
2:00-2:20PM	Pre-set small battery-operated lights in the car		
2:20-2:45PM	4. Marcus in car	Marcus on phone calls for business; describing neighborhoods that are blighted as he drives around	Cam 1 in car, Cam 2 gets exteriors of car driving away, meets us at his home
3:30-5:30PM	5. Marcus's home	Marcus interacting with his kids	Cams 1 and 2—set-ups with kids arriving home; Marcus as involved dad, giving kids snacks, looking over homework.
6:00PM	Wrap crew		

Build your shooting schedule to take advantage of scenes that normally occur in your subject's day, and identify goals for each scene.

Credit: Amy DeLouise.

For re-enactments, specific shots are often required in order to convey the story. But working with real people, you have to be strategic about how to plan your coverage. You won't have actors who hit their marks every time. You might even be filming something where you don't have the ability to stop the action. So how do you get your coverage? Producer Molly Hermann, who specializes in historical re-enactments, has some specific suggestions. For the *Civil*

77

War 360 series she produced for the Smithsonian Channel, one scene involved nurses and wounded soldiers in a hospital.

> ***At one point Lincoln came through and shook hands with people. Walt Whitman came through. So we used a camera on a slider—a Cam Tram System®—and also shot a round of handheld and also on sticks. We also had one camera person get up on a ladder for a master shot, and used a 5D for some insert shots of the nurses with their instruments.***
> (Hermann: interview, July 13, 2015)

The team also shot time-lapse sequences. Because the action might not unfold quite the same way each time, the idea was to create a pool of "generic but interesting shots" to choose from. This is a great way to plan your coverage with re-enactments involving real people. The goal is to let the story unfold as naturally as possible, without an exhausting number of retakes, while still offering sufficient coverage for an efficient edit.

CONTINUITY SAVERS: INTERSTITIALS AND TRANSITIONS

We've talked in Chapter 2 about shooting "interstitial" sequences. These are edit-savers when a shot sequence gets interrupted, and discontinuity of time and action requires some kind of edit transition other than the dreaded dissolve. Consider including at least one such sequence for every major category on your shot list. So, for example, I was shooting a young woman preparing dinner with her husband. The dialogue was great, but I knew we didn't have a continuous sequence of action. And I wasn't shooting a cooking show, so the details of the dinner prep didn't matter. But we did

need to maintain some continuity. So we shot some close-ups of two sets of hands washing and chopping colorful peppers. It was a nice mini-sequence, the audio was useful, and it set the tone for a scene about being a couple. On another shoot, I planned to shoot a table filled with old black-and-white family photographs, since I knew that the family history was essential to the main challenge of the story arc. The only problem was that the scene as envisioned didn't really exist. The family photos were all in a box. Luckily, our subjects had a few empty frames still in boxes from their wedding day. And in my usual producer paranoia, I had brought a few more to the "set" (their home). We quickly "MacGyvered" a lovely set-up on a table behind a couch, and did a dolly move past it that helped cover a key part of an interview referring to the family's past. I'm told the photo arrangement is still in their home to this day.

Another nice sequence to have for editing reality transitions is shots with motion. You can always rely on the classics, such as lens flares, shots of cars passing through the frame, or feet walking along sidewalks. Or you can experiment with dramatic angles on buildings or the sky. Or use the camera as a first-person point of view (POV) walking along a hiking path. Whatever you can get in the can for transitions will help you convey story content about your characters and the real world in which they live and move.

CAMERA-IN-MOTION SHOTS

Speaking of moving, another tool I love to use when working with non-actors is the dolly. A dolly shot works nicely to establish a scene while hiding a myriad of non-matching action issues. The Dana dolly, with its stealthy rollers and varying track-length options, is a handy tool. Just a slight motion lends interest to a scene. Side-to-side action can be used to reveal a character from behind just about anything in the foreground. Pushing in gently will bring the viewer into the opening of a scene. When traveling in major cities with grip

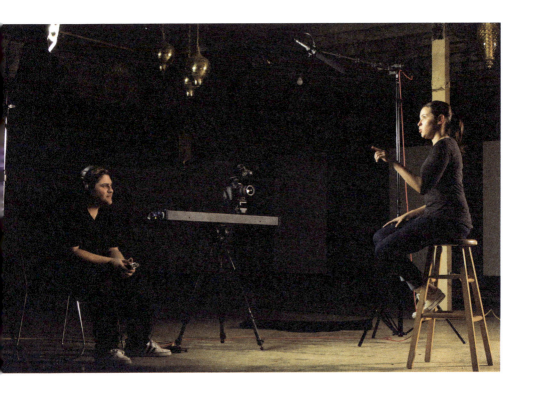

An automated slider adds interest and storytelling flexibility.

Credit: Courtesy of Redrock Micro.

houses, you can rent the rails to avoid lugging them through airports. There are several mini-sliders now available that offer similar results. If the dolly isn't your thing, try other tools for adding motion to your sequences. There are tools for every budget. From micro-sliders and small Steadicam™ rigs to mini-Jibs and Ronin camera stabilizers, there is an endless array of options. You don't want viewers to become seasick, of course. But including camera-in-motion shots on your list will have a major payoff in the edit room.

WHEN REALITY DEMANDS A SCRIPT

Sometimes a shot list and a story arc aren't enough. Certain production situations, such as limited-time shoots, require a clear road map

CHAPTER 4
PLANNING YOUR STORY

to help visualize how action, dialogue, or soundbites may unfold. This book isn't about scriptwriting, so we won't go into every detail on the process, but here are a few ways you can save yourself from re-shoots or excessive time in the edit room scrambling to find a story you didn't capture.

- **Define "must have" scenes.**
- **Define "must have" dialogue or soundbites—you can script them out (realizing they won't really happen this way), or you can jot down general themes ("Susan talks about Bob's upcoming surgery," "Ellen recounts the day the baby died," "Alyshia explains how her new prosthetic leg works.")**
- **Include at least one establishing shot per location.**
- **Identify "character" shot sequences—a few close-ups, shots of your main character not looking at camera, that may help you later as you introduce them.**

Sometimes I will then take all these pieces and actually construct a shooting script which provides a clear vision of a finished product. That doesn't mean I've prescribed every action. And it shouldn't mean that we can't capture other scenes once on location, or decide to start with a different scene once we're in post-production. But I find that a shooting script for some reality environments helps me to plot out my shot list more effectively. It allows me to visualize the scenes, and see if there are set-ups I hadn't previously considered shooting, or some kind of scheduling bottleneck I had missed before. The fun of reality content is its ever-changing nature. So "pre-scripting" as I like to call it, should not hamper your ideas, but rather provide you with the scenes and options you need to make your editing process more creative.

CHAPTER 5

CREATING THE BEST ENVIRONMENT FOR REAL PEOPLE

Andy Collins

WHEN I WAS NINE years old, we moved from New York City to suburban Maryland. What hit me first, as I walked the long hallway to my new 5th Grade classroom, was how different it smelled from my old school in New York. Not that it smelled bad. Just different. Foreign. I looked around the room and saw no familiar faces. And everyone already knew each other from their many elementary school years together. Thankfully, my teacher was kind, and painstakingly coaxed me to participate, and make new friends. When real people are under the spotlight of your camera, you are that teacher. And they are the vulnerable new students. It can be overwhelming to step into our universe of camera equipment, technical terms, and people who have worked together and told jokes to one another for years. Even the most experienced and media-trained individuals will have a fleeting sense of insecurity—the same one I had walking into that unfamiliar classroom so many years ago. So imagine what it is like for a person who never interacts with cameras. They could be a young child, or someone with a story of heartache or abuse to tell. The experience can be daunting. As a producer, my job becomes part maître d' as I introduce everyone, and make sure our featured people are made as comfortable as possible.

As a director, my job is a little different. I need to tap into those authentic qualities of the person we want to film, draw out their essential story, and make them shine on screen. You could call it tapping into their inner performer. But at the same time, I've got to be careful not to turn them into someone they are not, performing on command. Your best tool for accomplishing this is your empathy. Connect with the person on a truly personal level. Maintain eye contact throughout an interview. Nod and respond. Lean in. Body language communicates that you are connected. If you are directing b-roll and need them to re-enact something, don't just consider them as a pawn in your operation—or worse, an unpaid actor. As documentary director and DP Richard Chisolm explains, if by asking for a particular action over and over, you convey that there is "something I need and you can't give it to me," you are likely to damage the relationship with your subject. Instead, Chisolm has a different

mindset. "Before every shoot I remind myself that I've been given the privilege of being here as a guest . . . whether we are walking onto a construction site or into a home or a hospital room." Putting yourself in this frame of mind will immediately cue your subject that *they* have control. And feeling more in control will help your subject open up, and be more natural in b-roll and any speaking they need to do. Rather than making them the *object* of your shoot, make them *part of your team*. It's a difference that requires a conscious effort on your own part, as director and/or producer, and for every member of the team. Preparing the team is also helpful.

YOUR CREW

Educate the Crew

Your crew is made up of industry professionals. There are protocols and language on set that they expect to see and hear. Yet when working with real people, these on-set rituals can be intimidating or confusing. Depending on the sensitivity of the people or situation, you may want to convene crew early, or connect with them via email, to convey the language and demeanor you expect. If I'm going into a high-poverty area, for example, I might ask for flashy cars to be left elsewhere and the crew will travel together by van. If we're going to be in a hospital setting, I might remind everyone of what happens if a code is called while we're working, and plan for all our equipment to be in rolling bins so it can be moved out of the way at a moment's notice. It helps to have scouted your locations in advance and pre-interviewed your real people, so you know what to expect. Shouting "Action!" might intimidate one person. For another person, it makes them feel excited and happy to be participating. I have found an almost universal love for the slate, which is a good thing since I'm a fan of using them to make footage ingest and editing go more smoothly (more on that in Chapter 11). You will have to feel your way

on which terms you can use with certain subjects, and which ones to avoid.

Generally, it's best to avoid industry terminology while on the shoot. This is incredibly hard to do. You can't help saying things like "Let's go back to one," and "Can we walk in the Inkie a few inches?" But when you use industry terms, you create an environment that starts to feel foreign to your subject. Of course, you have to communicate with crew. But try to give technical directions *sotto voce* and out of sight of your subjects. So many times, I've heard an interviewee say "Oh, am I not doing this right?" when someone from the crew has blurted out something our subject doesn't need to know, like "I'm hearing a little hum..." or "I'm getting a hit off that window." This is why I love to work with teams who are right for the job. Not just the technical job, but the personalities and sensitivities that may be involved.

Introducing your Team

If you had a party, you'd introduce new guests to old friends. So why wouldn't you introduce your crew to someone you are taping? And yet so many folks forget this simple act of welcoming. I typically introduce people gradually. A PA or associate producer might be the first person your subject meets. Be sure he or she is prepared, knows their name, and is genuinely happy to meet them. The sound person might be the next person on the greeting list, as he or she has to place the lavalier microphone. If a makeup artist is involved, then he or she might be one of the first crew members introduced. Once makeup and sound are finished, we might walk through a rehearsal, and at that point meet the rest of the crew. The goal is to avoid overwhelming someone. And first names are sufficient—you're certainly not expecting your subject to remember all these names. The idea is to make them feel like part of the team, not a visitor in a room full of strangers.

Using Hair and Makeup as a Way In

"I don't have the budget for makeup." I know, I hear it all the time. And many times when you or a PA handles the nose powdering, you might get away with it. Then comes *the one time that changes everything*. If you're lucky, it comes early in your career, so you can recover elegantly from the experience. Perhaps it's a time when the CEO starts to sweat profusely. You can't keep getting up and down with tissues, as it breaks the connection you've built through the course of the interview by embarrassing her. Or there's a time when a person's flyaway hairs just won't stay put. Of course, you're working on deadline in front of a green screen. The edit schedule unravels even as you roll.

Whatever the situation, a makeup artist can be a life-saver. And for $600–$650 a day, compared with thousands of dollars a day for editing, what a bargain. "You're paying for someone who has solved lots of problems and knows how to handle every situation," says stylist Kim Foley (interview, May 8, 2015). "I come to the set with every possible tool—from ear and nose grooming tools to anti-shine products, not to mention double-stick tape for hidden microphones." Sometimes an interview subject or on-camera host will be very challenging to work with, and I can rely on professionals like Kim to run interference. Kim recalled an experience on a military base when a high-ranking officer needed to appear on camera. The lighting conditions and his skin tone were such that he really needed makeup, but refused to wear it. When the director pleaded that it was a must, Kim saved the day by declaring, "You're a Marine, you can handle it." She got a big laugh from the Marine, and he agreed to be made up. Being a go-between for director and subject, making sure someone looks their best, and being another set of eyes on your monitor—these are all valuable traits a credible stylist lends to the project at hand. It's also worth remembering if you are considering "putting powder" on an on-camera subject yourself, that the act of applying makeup to a person is a very intimate experience. Dabbing powder where a man's hairline is recessed, and smoothing flyaway hairs on a woman

CHAPTER 5
CREATING THE BEST ENVIRONMENT

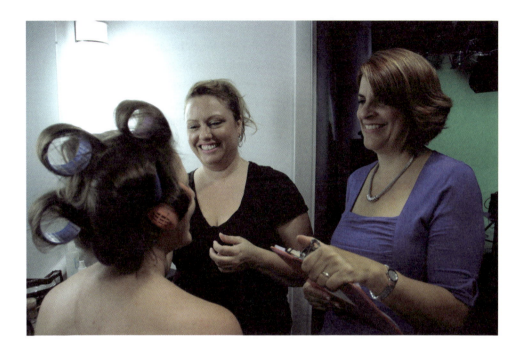

A good makeup artist can bolster the confidence of a non-professional on camera.

Credit: Photo by Wendy Faunce.

who is already self-conscious, can create an obstacle if not done well. The best stylists know how to establish a bond quickly with their subject. This connection often provides the needed confidence to a non-actor that can mean the difference between an acceptable day of footage and a great human story.

CHALLENGES AND SOLUTIONS

Managing Executive Producers and Handlers

I once worked with Justin Bieber for a direct-to-camera public service announcement (PSA). Not surprisingly, he arrived with a large group of handlers—almost too many people to fit into the small room we had been allotted. Our time was severely limited, as we were taping

87

in between his run-throughs for the *Christmas in Washington* broadcast special. Justin was totally committed to the children's health cause that was our PSA subject. His sincerity came through loud and clear. Except that one of the handlers kept getting in his eyeline and causing him to look off-camera. Luckily, we had anticipated extra bodies on set, since we were taping many music industry "heavy hitters." We had a large monitor already set up. I invited this particular team member to gain a better view of the action at the monitor, thus pulling him out of eyeline. Problem solved. Sometimes even people who work in our industry aren't totally aware of what you are trying to accomplish on set. In this regard, you could say, "performers (and their teams) are real people, too." A handler's job is to keep their executive, boss, or celebrity from looking bad or getting distracted. Be respectful of their jobs. If they are successful, it usually helps you be more successful.

Okay, but what about handlers who just insist on making your job more difficult? Well, we've all run across these folks. And I have once or twice had to have words with them. You have to be able to read the personality type to determine how best to accomplish your goals here. If this is someone who is feeding off the vibe in the room, then words need to be had in private. If this is a person who has positioned themselves in such a way that you can barely interact with your main subject, then sometimes you have to cut that cord by stepping forward and having a quick, private interaction with your on-camera subject. I once was conducting an interview with a well-known CEO. It was an outdoor setting that would best showcase his newly purchased sports team practicing in the background. He was chewing on a cigar, which I knew was not going to reflect well on him during our discussion of a health topic. The handler was buzzing around me, giving me a second-by-second countdown on how much more time we had to do the interview. My best shot was to come up to the CEO to adjust his shirt, while making a quick humorous reference to the cigar. He got it, immediately. And got rid of it. The handler glared, but we got what we needed. And frankly, the CEO probably didn't even notice the potential inconsistency until I pointed

it out. He might have even asked us to toss out the interview later, if the cigar had been featured. So your best shot at managing handlers is to demonstrate to them, and the subject, that you have their back. Everyone wants a good outcome.

Tapping into the Inner Performer

The first re-enactment I ever directed was a background sequence in a 30-second PSA. The scene called for kids on a playground as background action for the primary character, a little girl sitting alone on school steps in the foreground. The casting call brought in about 15 kids, many of them girls. I had sketched out a few ideas, and planned on at least one cutaway with the swing set, to be shot by our excellent DP Sheila Smith using her Steadicam® rig. It quickly became apparent that a game of hopscotch would play better in the immediate background of our establishing shot. It didn't take much work to convince a group of girls they could play a game of hopscotch. And then they started singing a little ditty that included the words "Call the doctor and the doctor said. . .," which tied in perfectly to our health-related theme. So our sound person got in real close for some just-for-audio takes, and then Sheila moved inside the hopscotch group to shoot a brief sequence. We all sensed that this was going to make the perfect cutaway and soundtrack for the spot, and it did. My takeaway here is that even in a structured story like a 30-second spot, where you have very specific shot sequences storyboarded out in advance, when real people are involved you can still get what you need by taking advantage of action that evolves organically. This is the beauty of working with real people on camera—especially children. They can sense inauthenticity a mile away. But if you respect what your real people bring to the story, if you give them the latitude to do something or say something instinctive, you will have a much better story in the end. This is where all your advanced planning comes to bear. Because you have already had conversations in advance with your subjects, you understand where they are coming from, and have developed a relationship before they walk into the lights.

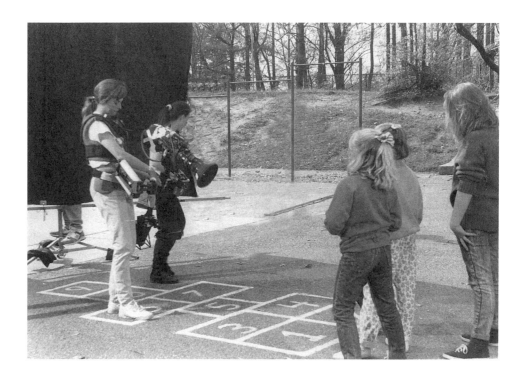

Film children in natural environments whenever possible.
Credit: Kim Foley and WIFV-DC.

When coaching is necessary, you'll have to do it more conversationally. In the PSA, I had to help the little girl who needed to look sad by asking her to think about something that would make her feel that way. That's a bit like talking to an actor about motivation, but not really the same conversation because a non-actor doesn't have a process that they consistently use to tap into their emotions. I see my role as part tour director, part film director. I want the shots to look great. I want the sequences of action to make sense for the story. But I also need to make sure that our real people feel engaged, supported, even happy about participating. So I spend more time chatting with them before we roll than I would with an actor. In fact, that process might be distracting to a professional actor, who needs to go through their own rituals of preparation.

Adversarial Situations

Every now and then, as a director or producer working with real people, you will encounter a "hostile witness" situation. This happens more often in a *60-Minutes*-type news interview, which is not the subject of this book. But occasionally, when interviewing for a reality show or documentary, directing a re-enactment with real people, or creating a direct-to-camera message, your primary character will become difficult. How do you deal with that? If you've done the steps above, and created a sympathetic, friendly, and welcoming environment, you've gone a long way to diffusing potential issues. If someone does become detached from your team—and stress can do that to anyone—walk away. It's as simple as that. Tell the crew to take a break. Take an early lunch. *Get out of this person's space.* The entire project is at risk if you lose your subject. Or an entire day's worth of shooting material that they now don't want you to use. So it's not worth pressing onward just for the sake of a schedule.

Once, on a multi-day production with a smallish crew of five, our extremely engaging, charming documentary subject suddenly called me and cancelled our afternoon shot. We had just left her at her office, and were heading to her home for another set-up with the kids after school. Apparently her spouse had called with concerns about being part of this shot, or maybe that wasn't really the whole picture. At any rate, it was just not going to happen. I said, "No problem," and gave the gaffer and sound engineer a 2-hour coffee break. The DP and I went off to shoot some establishing shots in the neighborhood. We missed the shot with the kids. But our exteriors turned out to be critical "glue" for an unforseen part of the story. More importantly, everyone was in a better mood for an evening shot with the whole family after dinner. So it all worked out. If we had pressed our case and insisted on that after-school shot, we might have lost the entire day. It's often hard to remember, when you are in the thick of production, that the real people in your film are not paid professionals. They have lives and other things to do. And when we can be respectful of that, and listen to non-verbal cues about stress, we will be better storytellers in the end.

GREEN SCREEN: WHEN IT WORKS, WHEN IT DOESN'T

Much has been written about David Fincher's green-screen work in *Gone Girl*, where subtle details are filled into the background of scenes. Everything from distant glistening lawns outside a home's palatial windows to an added hotel sign in a street scene, each detail adds to the mood and complexity of the narrative. The green-screen sequences were months in the planning. If you are producing with real people, chances are good you do not have the same time, budget, and staffing of a David Fincher project. Consider this as you decide about green-screen work environments.

That doesn't mean I'm against green screen. I just produced a fairly complex 4K green-screen shoot with three non-actors. The final sequence will reveal them walking through a virtual reality filled with images. The shot was accomplished by having them walk on a treadmill painted green, taping with the Sony Alpha a7S. The production team took a month to storyboard, shoot proof-of-concept shots, test the green-painted treadmill, and design shooting boards. During this preparation period, I spent time getting to know the people involved via several lengthy phone and email conversations. And that will all happen before we ever bring them into the studio. Also it helped that they are in their 20s, and had a lot of fun shooting this project for a non-profit organization they care about. Using green screen for an effective outcome in this case made sense. Using it just because you can, doesn't.

Green screen comes in particularly handy for direct-to-camera virtual environments where you need to communicate quickly many layers of subject matter. Educational outreach pieces and internal training applications are great examples of productions that can benefit from green-screen approaches. There are several different camera set-ups that work well for green screen. If you use a pop-up green-screen backdrop, you may not have room for a second camera angle. But sometimes you can sneak one in, and this gives you a little wiggle

room in your editing. Many corporations and non-profit organizations have small green-screen "studios" that may even be a former office or conference room. These can work well for a talking head or interview. For more extensive virtual sets, you'll either need a larger space or a big studio. I've even set up large green-screen backdrops in an employee dining room and behind an air-wall in a training center. Without a lighting grid, it's vital to have enough stands and fixtures to give you the even lighting you'll need to make final compositing easy. If you can possibly do it, shoot test shots and bring them into an edit suite to make sure your lighting is even and your key will work. Despite all the advances in digital compositing, you don't want unnecessary challenges in your post-production workflow.

Despite the creative opportunities of green screen, it's wise to consider whether it is the right environment, particularly for an interview.

Green-screen environments require confidence.

Credit: Photo by Wendy Faunce.

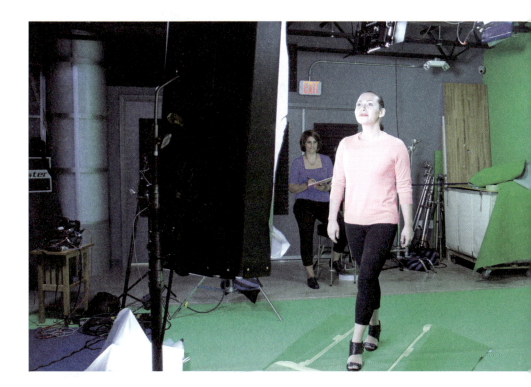

As you know, I feel strongly that there's not a "real person" alive who feels comfortable surrounded by a sea of green. It feels unnatural. It adds to the surrealism of the camera and lighting environment. I've seen it throw off even the most experienced of interview subjects. Another concern I bring to keying in backgrounds is that the decision about the background is not made as early in the pre-production process as it should be. Remember when we talked, at the start of Chapter 3, about the idea of location as character? Well, just because a location is digitally inserted doesn't make it any less a character in the film. So the idea that you'll "throw in a nice living-room background later" makes me cringe. Especially if you are not shooting background plates from, say, your subject's own living room. How does the digital background inform the story? How does it provide any information about who your interviewees are as characters? If you're planning to use a stock photo as a background—and yes, in several tight budget spots I've had to do this—you are potentially creating visual misinformation. So if you don't truly have time to plan out your green-screen scenes, or if you're using an in-house green-screen set-up just because it's there, please reconsider. If green screen truly remains your must-have tool of choice, then take a look at Jeff Foster's detailed *The Green Screen Handbook: Real World Production Techniques* (2015).

CHAPTER 6

WORKING WITH CREW

Andy Collins

A GOOD PRODUCTION TEAM is mission-critical. But whom you choose and how you bring them into the creative process can have a significant impact on your story, particularly when working with real people on camera. Professional actors are accustomed to working with a wide range of crew throughout their careers. Real people generally aren't. An actor may not love a particular crew or on-set dynamic, but they generally can rise above it. Real people may struggle. They may be thrown off by the way crew talk to one another, to our "Can you top this?" stories of production melt-downs shared during meal breaks, and to the language we often take for granted (the "F-word," for example—and believe me, I'm no angel on this one. My husband says I was a pirate in another life). All of these natural parts of production life can suddenly become liabilities when working with real people. Don't worry. There are a few strategies that can make crew your best allies in storytelling with real people.

FREELANCE TEAMS

Freelance crew may work on a different story every day of the week. Many of them move between fiction and non-fiction genres. This can be an incredible advantage for any producer or director. Your gaffer may just have had to solve a similar lighting challenge, albeit on a multi-million dollar movie. Your DP may have just got a new camera slider to deal with just such a visual challenge. Try to talk through the story arc in advance with any freelancers on your team, and share your shooting script with them. Make sure they know who the critical characters are, and any obstacles you foresee to telling the story. This could be as simple as saying, "Susan does more of the talking, but we need to highlight Elizabeth more in this scene."

If local freelancers are joining your primary team which has been together on the road for 3 weeks, you have another challenge. You've all had time to get used to the characters, the evolution of the story, some sensitive situations, or some funny happenings. Try your best—or assign someone else—to bring the newcomers into

the loop. Invite their input. Even if you're only together for a single day of shooting, the footage will be better when you have the entire creative team unified.

SETTING EXPECTATIONS

The best way to limit any negatives is to set expectations up front. If I'm working on a sensitive subject on a military installation or in a hospital intensive-care unit, I will give a heads-up to all crew via email in advance of the shoot. "Hey folks, just a reminder we're working with parents of super-sick, even dying, kids today. Not to be a downer, but just wanted to remind you that our usual jokes may not be appropriate tomorrow. Thanks!" In other situations, the crew might hear information that can't be shared until the show airs. Or, I might need to remind everyone of a dress code: "Hey team, just a reminder that since we're shooting in and around a mosque, no short pants, ladies keep a head-scarf handy." Setting your expectations clearly in advance helps everyone stay out of trouble.

SELECTING THE RIGHT TEAM

The most important factor in setting the right tone from the start can be who is on the team. Personalities matter. Several DPs I've worked with are tremendous with very shy people. Others excel at working with kids. Still others are like bulls in a china shop, and though I love them dearly, I don't book them for those kinds of shoots. Sound people often interact the most intimately with folks, because they help put on and take off microphones that may need to be wired inside clothing. So having a personable soundie with good EQ—emotional intelligence—is an absolute must.

CHAPTER 6
WORKING WITH CREW

BUILDING TEAM PLAYERS

That makes it sound like new people can't ever get a break—and it is hard to be the new kid on the block on a production team. If you have new folks on board, take time to bring them into the fold. Production assistants and grips just starting out may not understand the "givens" of production. They can miss the unspoken rules, which can have an impact on the entire team and the real people you are working with. If you happen to be one of those people starting out, find someone willing to answer your questions. (Hint: This may not be the person who hired you.) Offering to bring everyone coffee is always a good first step.

When a production team works well together, real people on camera can do better storytelling too.

Credit: Courtesy Refined Creative.

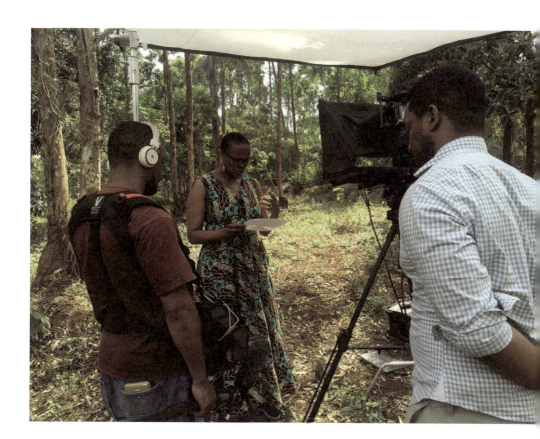

99

WHEN YOU *ARE* THE TEAM

What if you are the *whole* team? More and more in my workshops across the United States, I'm meeting amazing people who are expected to write, produce, direct, light, shoot, record sound, and then edit and design graphics for their entire projects. To me, these are all separate jobs with very distinct training and expertise to bring to the project. And as a producer/director, I value the different perspectives that others bring to my productions. If you are talented enough or crazy enough to be doing all of these jobs, then you're obviously good at wearing many hats. How you relate to the person before you on camera, how you interact with them, will need to vary from project to project.

Consider adding on some extra hands—even just one PA to help keep track of some of your production elements while shooting. This will allow you to focus not just on scenes and camera set-ups, but the all-important human relationship with your subjects. Producers taking my workshops often tell me stories about how they were so concerned about lighting a shot that they didn't realize the interviewee was getting too nervous to appear. Or as a shooter-audio tech-director, they were so involved in listening to headphones to hear how the dialogue in a re-enactment was unfolding, that they didn't realize a glaring error in the sequence of action. When you wear every hat, you will always compromise on some aspect of your production. You can quote me on that.

FOOD MATTERS

Once you've had to hunt down crispy bacon on a croissant at 3AM in the middle of the National Mall (Washington, DC) where everything is shut tight, you can pretty much handle anything. One of my early freelance gigs in the industry was serving as a location PA and craft

service maven for various feature films and TV movies. I often spent the wee hours loading and unloading my hatchback with enough food to feed a small country. It didn't take long for me to learn that a production team, much like an army, travels on its stomach. Flash forward; I'm working in non-fiction production where food is considered some kind of luxury. I have never understood why. It's not a budget-breaker. By contrast, when you feed people, they work more efficiently and you tend to wrap sooner. It's a much more pleasant experience for all involved. And frankly, less cranky people are more likely to be helpful in a challenging situation on set. If you take one thing from this book, it should be this: Feed everyone. Thank you.

THANKING AND MENTORING

Speaking of thanking, please do that, too. In the non-fiction world, we tend to be on tight budgets. We work on difficult stories. Documentaries can be years, even decades, in the making. And our crew may often be underpaid. Thanking people and mentoring up-and-comers should be a natural part of doing business. It's a way to pay it forward. And with all the social media platforms at our fingertips, it's so easy to do. When you post a link to the documentary on your Facebook page, take the time to tag all the crew people who worked on it with you. Tag them in behind-the-scenes photos on Instagram. Endorse them on LinkedIn. And "off line"—i.e., the real world—invite an extra PA on your journey and train him or her to become the next great non-fiction director. What's the expression about karma? Exactly.

CHAPTER 7

DIRECT-TO-CAMERA DELIVERY

Andy Collins

DIRECT-TO-CAMERA DELIVERY USING NON-ACTORS is not for the faint of heart. I once directed an educational mini-doc on teenage drinking in which a teen counselor was to be a featured interviewee. My plan was for her to serve as narrative glue and developmental context for the teen interviews, which were held with high-schoolers who ranged from non-drinkers to heavy drinkers. As we were setting up the shot, however, our interviewee made it clear that she wanted to deliver her remarks directly to camera as a host. She felt that commenting directly about the various issues explored by the film would be highly effective as segment introductions. Her instinct was right. But the stylistic curveball meant we were not prepared with a teleprompter, which she said she wouldn't use anyway. Delivering accurate and sustained delivery without a prompter turned out to be a real challenge. After several busted takes, my clever DP rigged up a mirror adjacent to the lens, so that my subject and I could at least retain eye contact, which helped us both survive the experience. Her genuine passion for the subject translated on screen. But it took 17 cans of film to do it—about 3 hours of raw footage for 3 minutes of screen time, and the equivalent of budget Armageddon. Masterful editing and the fact that our host did really know her content helped us create a great, award-winning film. But I had learned a painful lesson about directing real people: Speaking to a lens is more difficult than it looks. Professionals make it look easy because they practice the art daily. For even the most experienced of subject experts and public speakers, speaking naturally to a lens is hard. And coaching an authentic delivery poses a special challenge for any director. Success involves blending two key roles: cheerleader and coach, but with a light touch in each category. Let's tackle several common situations and how you could handle them.

DIRECTING EXPERIENCED SPEAKERS FOR DIRECT-TO-CAMERA

One of the challenges of working with a subject expert on camera can be the very thing that makes them engaging in real life: the way

they connect with an audience. The camera offers an audience of only one, and an inanimate one at that. Accustomed to presenting before crowds, your speaker will yearn for feedback. That will cause "shifty eye syndrome" as they unconsciously glance around the room, trying to make a human connection for their message. The only people who can provide this eye contact, unfortunately, are you and your crew, and gatekeepers or executive producers in the vicinity. It's your job to help the speaker avoid this eye contact and deliver their remarks with confidence. There are some concrete ways you can help.

Privacy for your On-Camera Host

Shoot away from onlookers, co-workers, and anyone else who might be an unnecessary distraction. Offer a separate viewing room and monitor whenever possible to handlers, EPs, creative directors, and others who may be essential to the production, but are not on the immediate crew. Give these participants ample and specific opportunities, agreed upon in advance, to weigh in and give feedback. If you don't do this, you're likely to get feedback anyway, but perhaps when it is too late, or your "talent" is too tired to do retakes well. You might hear, "I didn't want to mention this before, but Bob kept saying T-I-P and we're actually calling the initiative TIPS." Oh great, now we have to re-shoot everything.

Coach to the Crowd

For experienced speakers, help them imagine their crowd inside the lens. Describe the kinds of people who will be watching the show. Help your host imagine these folks as their true audience, with the lens as a vehicle for making the connection. In an absolute jam, I've even put a smiley face on a sticker just below the lens. It works!

CHAPTER 7
DIRECT-TO-CAMERA DELIVERY

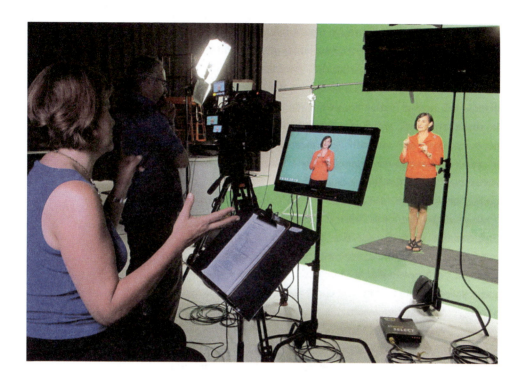

Experienced speakers still need an audience. Give them plenty of feedback.

Credit: Amy DeLouise.

Create a Calm, Supportive Environment

Hold distractions to a minimum and help your crew avoid eye contact. Put their monitors and yours on the floor. Be sure the sound mixing gear is not in an eyeline of your host. Physically go and check it out—you can't always tell by looking from the camera position. Make sure that crew members don't check messages during the shoot. Honestly, this should never happen while you're taping, but with long stretches of to-camera delivery, it can be a temptation.

Some speakers may need more feedback than others on their direct-to-camera delivery. You may need to remind the person why they are passionate about a subject: "Oh my gosh, Carol, you just won the top customer service award for your industry! Amazing!" At this point, Carol is smiling sheepishly. Give her positive feedback as you ask for help. "Help us show your excitement and tell everyone

this: Why on earth do you love working with customers so much?!" Some people respond best to enthusiasm with a side of humor. It's to be hoped you've spent enough time with the person to determine if this approach will be helpful to creating the best environment for them. When directing an experienced speaker, you may only need to provide the occasional supportive remark: "I liked that take." "You made the point nicely." "Yes, your tie is still straight, you look great." Give only as much as is needed.

Give Yourself Wide and Tight Framing Options

Gathering wide and close-up framing obviously gives you editing options. This is especially vital with non-professionals, who may not give consistent reads. If you can shoot in 4K, you'll have latitude for creating tight shots from wide ones without reframing. This can be a life-saver when you have a non-pro delivering quite a bit of copy, or working from bullet points where they might not match their words exactly with every take. If you're shooting in 1080p, which is the bare minimum these days, then you'll want to record a master wide shot at least for the open and close. If you and your subject have the time, shoot a master shot for the entire read. But if time is limited and you're not working in 4K, then shoot your tighter shot first. This will be your primary shot, and if your talent loses steam, you don't want only to have a wide shot to work with. Then go back and get a wide shot of the entire read, so you have edit coverage if different reads need to be pasted together.

Consider a Standing Delivery

I'm a fan of having folks stand up to speak, particularly if the copy isn't too lengthy and there are no health reasons requiring the speaker to sit. For many natural public speakers, sitting feels passive. Standing gives them confidence, and makes them feel more in control. They may also use their hands more naturally from a standing position.

CHAPTER 7
DIRECT-TO-CAMERA DELIVERY

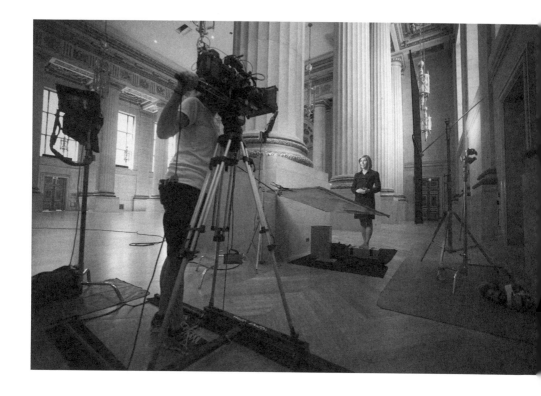

Professionals often stand when speaking directly to camera.

Credit: Courtesy of Spencer Grundler.

Watch out for someone who shifts their weight from side to side, or front to back, as this can undermine any advantages you gained from standing. Sometimes a high stool is a compromise. It still offers height and a sense of authority, but offers security that the speaker won't wander out of frame.

DIRECTING INEXPERIENCED SPEAKERS FOR DIRECT-TO-CAMERA

It happens more often than we'd all like to admit that inexperienced speakers are selected to deliver important information directly to the camera. Especially in internal and educational media, someone might be chosen for who they are (head of a department, the leader

107

of an initiative, the child of the executive producer), rather than for their experience on camera. That doesn't mean you can't direct a confident delivery. But your approach will need to differ from how you'd work with an experienced speaker. I've worked with students and even young patients in a hospital setting, who just need a little extra support to convey engaging messages directly to camera. So what can you as a director do to help these folks feel confident?

Some simple tools can help. Suggest in advance of your shoot day that the "host" practices a bit by recording themselves with their phone. Even though I have spoken before rooms with hundreds of people, before I taped my first online education course for Lynda.com, I did the same thing. Speaking to a lens is vastly different from talking to people who react in real time. The first thing that struck me about my pre-recording was that I didn't smile enough. Even *thinking* about smiling helps the delivery seem more natural and congenial. One way to learn this is to watch a cooking show with the sound off. Why cooking? Because food shows are rife with hosts of all flavors—sorry, I couldn't help it. These are real people who didn't start their careers to become on-camera personalities. They are doing what they love. And it shows. Because no matter the cooking style, what they all have in common is charisma. And each has a personal way of connecting to the viewer. From Giada De Laurentiis with her blazing smile, to Bobby Flay with his down-to-earth buddy-boy approach, you feel like a friend, a neighbor, someone with whom they are sharing confidences. They smile and you relax about following the recipe. Without the sound, you and your "talent" will notice what they are doing even more clearly. There is a lot more smiling than you might have first imagined. There is a little bit of "Let me tell you a secret"—a beguiling intimacy with the camera that is necessary for us to feel like we can connect one on one. No one is going to become a TV celebrity host overnight. But by practicing this approach in front of a mirror and with your phone camera, your prospective on-camera speaker can develop a little bit of that style. And every little bit of added friendliness and engagement will increase the impact of the message.

Another tool for encouraging a natural delivery from a less experienced speaker is to practice by doing a quick Q&A with them off-camera first. I often stand farther away than is truly necessary, and lean forward. This is to encourage a slightly louder speaking voice from the talent. It forces us both to connect on purpose, not simply by default. So I will chat a bit, ask a question to prompt the topic at hand, and then say, "Okay, great, this time when I ask you, just turn and pretend the camera is me, and respond right to it." Once we've done it a few times, and they get the hang of it, we can develop a rhythm to the questions and answers. Sometimes I can stop asking questions altogether. It's surprising how often this Q&A approach works quite nicely, and feels natural.

Working with Kids for Direct-to-Camera

Kids are naturals. Don't over-coach them. Do give them examples in advance from kids' shows they like to watch. Remember that audition pre-interview (discussed in Chapter 1)? Ask a few questions about shows they like, so you can reference them just before and during the shoot. Encourage kids to practice with their iThings at home. But the best thing you can do with kids is be a supportive cheerleader. Use the same tools for keeping parents out of sightlines that you use with other gatekeepers: Give them their own monitor, preferably out of the room. But check in periodically to be sure they're happy. Because a happy parent will be a great ally for you as you create a positive experience with your production team. And speaking of the production team, with young children, I like to play something I call "the invisible game." We walk around the room or the set and meet each member of the crew, learn what they do, and take a look at their equipment. Then we pretend they have all disappeared and it's just the two of us (and the lens). Kids are much better than grown-ups at pretending there are no crew to distract them. And kids are so much fun to work with that you'll have fun pretending, too!

OTHER TIPS FOR SUCCESSFUL DIRECT-TO-CAMERA DELIVERY

Memorizing Copy versus Teleprompters

I strongly discourage memorizing copy. That's why teleprompters were invented. And yes, I do recommend using prompters with non-professionals for direct-to-camera reads. But with this caveat: There is a skill involved in reading ahead without making your eyes shift. This is one of many reasons why professional TV anchors are so highly paid. They make reading sound natural. And they know when to vamp, and how to extrapolate from simple bullet points. Regular people just don't do this. Even if someone tells you, "Oh, I use teleprompters all the time," this might mean they use them a few times a year at conferences, or once a month for the company podcast. *But never for hours a day, every day, like a professional.* If you are running your own iPad prompter, you too may be inexperienced. Though you've done it on countless shoots, running a prompter is probably not your primary job. So when the budget allows, consider a full-time prompter operator or at least a PA who has some expertise in operating your system. I usually find these folks are well ahead of me, saving time and money along the way. When a person keeps stumbling over the same word and we have just decided to change it, my prompter operator is already re-typing and saving a new version of the script. When the on-camera subject struggles to read something, the prompter operator bumps up the font and is ready to go in a flash. If you can't afford a prompter operator, designate a PA to do the job rather than the shooter, so you can both stay focused on your respective roles of getting the best shot and coaching. If you rely on teleprompters a lot, invest in a prompter glass beamsplitter system. While studio prompter systems can run upward of $2,000, a lightweight prosumer prompter glass system for iPad and/or Android tablet costs under $700. It gives your speaker a far greater reading range than an iPad rigged directly beneath your camera lens. The beamsplitter glass allows a reader to

CHAPTER 7
DIRECT-TO-CAMERA DELIVERY

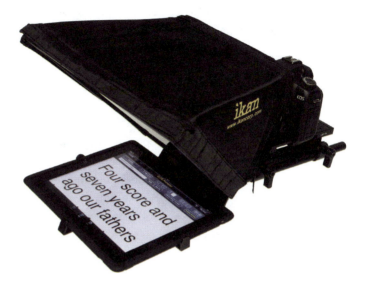

The PT-ELITE-U from ikan is one of several affordable options for tablet-based prompter systems.

Credit: Courtesy of ikan Corp.

see the scrolling text from more than just a head-on angle, so they can be more natural in their stance and delivery. Take a look at the inexpensive solutions on the market and ensure that you don't make reading scrolling text a difficult challenge for your speaker.

Using Bullets Rather than a Script

Using bullets can be very effective for experienced speakers who know their topic well. Rather than reading lengthy teleprompter copy, this speaker can key off the points and run with it. The result is a more natural delivery. That is, as long as your prompter operator can keep up with them as they segue from point to point. Make sure that the bullet order makes sense, and there is a natural flow to the story line. It's a good idea to add a broad introductory line, and a wrap-up line, and shoot these in a few different framings. All the reframing tips from earlier in this chapter also apply here, but with this change: Your camera may have to do some reframing on the fly. When using bullets, since the copy will never be precisely the same

on retakes, I tend to plan ahead for certain "on-air" zooms to be sure we have the right coverage for editing.

To Rehearse or Not to Rehearse?

Generally I subscribe to the notion that the fewer rehearsals the better. If you are working with a teleprompter, it will be necessary to give your subject the chance to see what it's like to lead, rather than follow, the prompter. Often they will slow down their read, and then the prompter operator will slow to follow them, until the whole thing is going along at a snail's pace. If we're not using a prompter, and I'm doing the Q&A approach, or letting the person speak to a couple of key concepts, then it's one rehearsal for camera and we're off. Once in a while, in a testimonial piece, I'll use a dolly. In that instance, we'll ask someone to be a stand-in for our "talent" while the crew masters the shot. Only then will I bring in our on-camera person for their minimal rehearsing. Then, we go. As always, the less intrusive the equipment is, and the less time your subject has to look at it and think about it, the better.

TESTIMONIALS

Boy, are testimonials fun to direct. Everyone is so enthusiastic and excited to be on camera. And thanks to the casting process we talked about in Chapter I, you are working with the cream of the crop. Still, there are challenges to overcome, and ways to draw the best out of these folks. Here are some of my tricks of the trade, whether these folks are speaking down the nose of the lens or to an off-axis interviewer.

- ***Hide the crew and gear.* I recently shot some direct-to-camera sequences with a group of people in a studio. The crew placed all of "video village"–the slang for all**

the cabling for sound and monitors–plus some standing light stands, and the makeup artist, behind two large silks rigged on either side of our two cameras. One camera was essentially a lock-down shot, while the side-angle camera was moving on a small jib. To minimize the distraction of this motion, even the jib camera rig was positioned so that it was partially obscured from the point of view of a seated on-camera subject. It's intimidating enough to shoot in a studio. So hiding as much gear as possible can help boost the confidence of your on-camera subjects.

- *Play dumb.* What I mean by this is, use facial expressions and other non-verbal cues, followed by looking toward the lens of the camera (if this is direct-to-camera delivery), to encourage someone to repeat themselves or say something louder. We are wired to respond to non-verbal cues since our days in the crib. So most people won't even realize they are doing a retake.

- *Play devil's advocate.* Rather than asking how much someone loves product X, or cares about non-profit cause Y, force them to contradict you. "So you were thrilled to take a drive in your ABC car before you got into this XYZ one, right?" No, she hated it! "So [the organization] has plenty of money to solve famine in Africa?" Of course not! But when they are contradicting you, people get much more animated in their testimonials. And animated people look and sound great on camera.

- *There are no wrong answers.* Only better ones. But you keep that last bit to yourself. Offer positive feedback and support for your testimonial-givers. Always channel positive energy on the set, and take any client or EP questions out of earshot of your real people. If they lose their train of thought or start getting tired, give them a break. I'm exhausted after a day

directing testimonials. My face muscles literally hurt. That's because I've been channeling positive feedback through non-verbal cues all day long. It's tiring, but the payoff is so worth it, because the testimonial-givers' excitement translates directly to on-screen impact.

CHAPTER 8

SHOOTING RE-ENACTMENTS

Andy Collins

"DIALOGUE TURNS GOOD PEOPLE into bad actors," says my colleague and DP Richard Chisolm. I agree. In the many scenarios I have produced, getting real people to handle dialogue realistically is always the biggest challenge. The other challenge is getting proper coverage of critical action. This usually involves some level of "re-enactment." So, the camera person may need to interrupt a moment to ask, "Can you bring your hand in toward the phone a little slower?" Sometimes it will be the sound person: "A truck went by and I didn't quite hear what you said, could you tell him that last part again?" In scripted reality TV, the requests may be even broader. "Can you talk to Sheila, and tell her how that call from Andrew just made you feel? Show us how mad you are about it." And then there is the scenario-based program—for a historical documentary or a training film—where the majority of the story is told through re-enactment. While the latter genre might use paid actors, often the people doing the re-enacting are playing at their actual jobs, or are hobbyists who have spent time researching a particular period of history. As the director and/or producer, you will have to elicit some level of re-enacting as you work with the real people in your story. So how do you do it without destroying their confidence? How can you propel the story and get the scenes you need? And also the audio you need?

If speaking is important to the story line, try to avoid interrupting the natural flow. For example, in a hospital check-in situation, you can pre-light the room for the exam, and say to the nurse well in advance of the patient's arrival, "Just ignore us and check Sarah as you normally would." Of course there is still artifice in the scene, since you will have had to get permission from the doctor's office, from the nurse, and from Sarah herself or her parents if she's a minor. The scene might require using a wireless microphone on the nurse, if she is a major character in your story. Boom microphones can be intimidating. But putting a wireless mic on every patient will hardly be an option. So you may have to compromise on some of your secondary character audio, or let your boom operator know exactly which dialogue is absolutely critical to the story line.

TIPS FOR KEEPING RE-ENACTMENTS ON SCHEDULE AND BUDGET

- *Shoot from multiple angles simultaneously.* Give yourself enough coverage that you could edit with no retakes.
- *Add motion.* Put at least one camera on a mini-jib or slider. There are many options to choose from, but for my money, the Dana dolly is the most flexible option for sliders because you can raise or lower the rails to any level, and add rails of any length from 4'/1.2m on up. Most Dana dollies rent for about $100 per day and include at least one set of rails, so it's a cost-effective tool for most reality shoots.
- *Shoot inserts.* In addition to standard close-ups, shoot inserts or brief "interstitial" sequences to offer story information and soundbite edit coverage. These can be of inanimate objects, trees, water, cars crossing, whatever can help inform the story.

So why use non-actors in a scenario? The major reason is budget. But another is expertise. Training actors in the minutiae of a military operation, a surgical procedure, or a factory installation would be too difficult, too dangerous, or both. Another reason can be more about intangibles. Says DP Matt Gottshalk, himself a Marine:

> **I've shot scenes where we had an actor and a Navy Seal, and I knew right away the actor was just not going to cut it. He just didn't look the part. I knew if we used him, even scenes he wasn't in would be rejected.**
> (Gottshalk: interview, July 14, 2015)

THE B-ROLL RE-ENACTMENT

The b-roll re-enactment is just what it sounds like: a mini-replay for camera so you have b-roll in the edit. Let's say you are shooting a documentary about farming. You want a shot of the farmer you just interviewed, flying past your camera on a tractor. But the reality is that the day you are filming, he's not planning to be out on that tractor. So you chat with him a bit about what you need. Then he goes to get the tractor while you set up your camera way out in a field. You wave your arms wildly to show him when to start driving. The giant wheels roll by and you get your shot. Or maybe you don't. Or you want an optional long lens shot. So you make him do it again. You have just directed a re-enactment. As story-makers, we do this all the time without even thinking about it. We know instinctively that telling without showing loses impact. We're right. But we need to be mindful when natural scenes unfold, and be better prepared when they do. Lightweight cameras are making this easier. But there is still a mental component at play. We need to avoid interrupting so often that we make our subjects self-conscious and disrupt the story process.

CHAPTER 8
SHOOTING RE-ENACTMENTS

Many documentarians sense a line they won't cross for a re-enactment. I know one documentary DP who prefers to get the "walking through the door" shot the very first time, and only from the outside angle, because by definition, doing it again, or jumping inside to get the reverse angle, smacks of an unnecessary re-enactment he believes looks fake. He's right. But from my producer/director vantage point, I might need to balance my desire for authenticity with maintaining some workable sequences for the edit. At the same time, I want to maintain a good relationship with my subject throughout the project. Even if we've agreed in advance that the crew can begin filming at the door, the reality often feels too invasive. During your pre-interview process, you will start to recognize when and where you will be able to get b-roll easily, and the locations or situations in which you'll need to stop and give the subject a moment before the camera begins to "see" the experience. It's a delicate balance. Added to the imposition factor is the danger of repetition. If you ask too many times for something to be re-done for camera, people will naturally assume you want this all the time. They will start to anticipate needs that may not even exist. They might even break a wonderful moment by stopping what they're doing to say, "Do you want me to move over so you can see this better?" Suddenly your real person has become a crew member, and the magical experience of being a fly on the wall has disappeared. Avoid this at all costs. Speak to crew in advance about a signal you can use if you need something from another focal length, for example. Avoid talking too much about external factors—street noise, dogs, children—that might make your subject hyper-aware, and less in their own real world. Every now and then, I forget this rule, and then I regret it. I want my real person to be, well, real. They're not crew. They don't need to be worried about technical issues. And certainly, we don't want them to be thinking about our b-roll shot sequences. The other thing to avoid is an inflexible list. Sometimes you are so hell-bent on getting a particular b-roll scene ("Won't it be fantastic if they're all playing pinball?") that you don't leave time for something else to unfold.

Improving B-Roll Coverage

In narrative filmmaking, you typically begin your shot coverage with a wide shot, then proceed to medium shots, close-ups, and reverse angles. When working with real people, I often reverse the sequence. The reason is simple: Actors will repeat with precision, and may even improve with practice; real people will not. With real people, I want to get any close-ups and personal interactions the first time, when they are "fresh." I especially want boom sound from the start. (Yes, sometimes I put lavalier mics on people, but I prefer the better dynamic range of boom sound, or the ability to mix boom and lavalier microphones.) I can cheat my use of a wide shot, without the need for precise repetitions of action or dialogue, since I know we can cut in and out of this shot, or perhaps only use it once to establish the setting. If I've also shot the interstitial scenes we discussed in Chapters 2 and 4, then I will have enough coverage to make the editing work. That doesn't mean I won't repeat any shot in the sequence. But I might not repeat it precisely. So for a dialogue between two people sitting at their kitchen counter, I might have one or two static two-shots of them talking. Then, we might get the same two-shot as a pan up from one of their hands. The next pass might be a pan from the left, landing on the two-shot. I want options, but I don't want to interrupt the conversation to make them "start it again" too many times, if at all. Many producers believe that since we have moved into the digital world, the necessity for a "safety" take is gone. Big mistake. Digital media can get corrupted. So my preference is always to have at least two versions of my most vital shot—the medium two-shot—in a scene with real people. If I can light the scene in such a way that we can move seamlessly into close-ups, that is ideal. Depending on the seating position of our two heroes, we might not be able to get away with full over-the-shoulder coverage without adjusting lights. But we might be able to plan for both our two-shot and a single without adjustments. This will make for faster footage acquisition, and most importantly, less intrusion.

Challenging B-Roll Re-Enactments

There are times when getting good b-roll challenges even the most experienced crew. The run-and-gun shoot is the most obvious. You need five interviews in 3 hours. The best approach is having two cameras and a thumb drive. Let me explain. If you only have one DP, you could lock down your primary interview shot for a couple of very basic questions toward the end, and let him or her grab the second camera to shoot some b-roll of hand gestures and other coverage from a side angle. The thumb drive is to collect stills that you've already discussed with your subject during your pre-interview.

Another challenging b-roll environment is any medical situation. You can hardly ask the mother of a cancer patient to kiss her child tenderly again, or the surgeon to cut again, or the anesthesiologist to hit the drug-delivery button again. In these situations, I roll with the live experience, and actually place an emphasis on audio rather than

A staged discussion with the subject can propel a story.

Credit: Courtesy of Fur Face Film/Her Aim Is True production.

picture. Sound will be critical to establishing the emotional content of the scene. If picture is busted, you can still use the audio while cutting away to something else—a close-up on a hand, a sign on the wall, a piece of medical equipment. So it's important to add close-ups and insert shots to your coverage of the scene. But if you don't have primary sound, you lose the essence of the story.

Another difficult scene to cover for b-roll is the discussion circle. When possible, it's nice to have coverage from inside the circle. But sometimes this can be too intrusive. I might negotiate for the sound person to stay outside the circle (the boom from several yards away can still pick up enough to establish the interactions going on), but for camera to be able to sit on the ground inside. Holding the camera on your lap and watching action on a flip-out screen or small externally mounted screen rather than the eye-mounted viewfinder will make participants feel less "watched" and less self-conscious. For any challenging b-roll situation, including tight physical spaces or those sensitive situations in which having a sound person and a boom microphone would be intrusive, you can mount a good-quality microphone onto your camera and use "camera mic." Go too

DP Richard Chisolm believes building relationships with subjects is the key to getting great footage.

Credit: Courtesy of Richard Chisolm.

high-end with this mic, though, and you'll actually pick up too much bumping and movement of the camera. Go with the low-end built-in mic, and you won't have usable sound. A good compromise is a Sennheiser ME66. The main point I want to make here is that you must respect the people and the situation at hand. Your production will reflect that respect. You might not have the same sequential coverage you would get with a feature film, but the essence of your characters will shine through in other ways.

FULL-SCALE RE-ENACTMENTS

Nothing is more challenging than re-creating history on a budget. But that's exactly what Director/Producer Molly Hermann does for a living (interview, July 13, 2015). And she loves it. Hermann and her team specialize in historical re-creations on video. While she sometimes hires professional actors, just as often she casts hobbyist re-enactors or folks in the neighborhood of the shoot using Craigslist. Hobbyists bring a wealth of knowledge and authentically re-created costumes to the production. But even with well-informed participants who cover the cost of their own costumes, there are challenges with using real people and not actors. "Realistic dirt isn't easy to apply," explains Hermann, "and many military re-enactors have beautiful gear they don't necessarily want covered in mud." In addition, she notes that modern people are much cleaner, and frankly a bit heftier, than people from the 18th or 19th centuries. "It's hard to say don't wash your hair for a month before we shoot, but that would be truly realistic." To get around these challenges, Hermann sets up master shots and multi-camera coverage, then goes for medium shots and close-ups on a few select players who might be a little leaner, and purposely less tidy, than the rest. Another suggestion from Molly for working with real people in re-enactments is to take advantage of their existing relationships to make a scene more believable. "If you can find people who know each other already, then you can say 'Oh that's your dad? Great, stroll arm and arm together.'"

Re-enactment DPs use a multitude of tools—from sliders to slow-motion shots to time-lapse—to get many coverage options on scenes. They also shoot insert shots, which are a great way to use less expensive cameras such as the Canon 5D. The key balance is to maintain shot coverage while not exhausting your "talent" team. There is an esprit de corps in large shoots that can either help you, or kill you. When everyone is working toward the same goal, and feels respected as part of the team, the production goes well. That doesn't just mean nice catering, although hot food on set is a big plus. It might also mean ensuring that your real people are able to hear directly from the DP how a scene will unfold, instead of only being directed to move around the scene by a PA. It might also mean respecting how everyone feels about the roles they are playing. One of Hermann's re-enactments involved having some of the residents of a Virginia town play enslaved people: "We re-created a slave

Director/Producer Molly Hermann works with real people to re-enact a preaching scene.

Credit: Courtesy of The Biscuit Factory.

auction inside this stone building, which everyone felt was a very profound, disturbing and moving experience."

SCENARIOS

Somewhere in between shooting the full-scale re-enactment and getting some b-roll falls another type of re-enactment: the scenario. Scenarios are brief stand-alone scenes, often with dialogue, to demonstrate how something is done. They offer one of the best video teaching tools. An even better tool is multiple scenarios: one showing the best way, and one or several showing what could happen if rules or procedures aren't correctly followed. To help people learn from scenarios that don't involve actors, you need to plan carefully. You want to avoid lengthy dialogue whenever possible. Pare down the story to its most essential parts. Shoot a wide master shot first (the opposite of what we do with actors, where we get dialogue first), so that everyone gets a chance to practice their actions before we get to the close-up shots.

Often, non-actors are playing themselves in scenarios. On the one hand, this gives them a high level of comfort with the actions you want them to do. This might mean feeding a baby, typing something on a computer, handling a product on a factory assembly-line, or re-enacting a surgical procedure. On the other hand, your on-camera subject is not familiar with the principles of shot framing and matching action. They are blissfully unaware that when their hand enters the frame with a baby bottle, you are trying to match a sequence of this action which you previously shot from another camera angle or focal length. Your job will be to coach them just enough to get what you need without causing your subject to become too self-conscious. Be especially sensitive to people who begin to "edit" their own actions—"Oh, I should have moved my hand faster, right?"—rather than giving you the opportunity to choose which takes you prefer during post-production. Using at least two cameras when

possible, and limiting your on-set technical discussions are the best way to keep your scenario moving.

Whatever kind of scenario or re-enactment you are directing with non-actors, remember that they are people, not professionals. Plan for shot coverage that gives you maximum editing flexibility, while letting your subjects' authentic excitement shine through.

CHAPTER 9

BEYOND THE SOUNDBITE
The Dance of the Interview

Andy Collins

ONE OF MY FAVORITE interviews to conduct was with Jeff Astrof, a comedy writer in Los Angeles. The interview was a challenge in the sense that as a TV show writer, Jeff's got a pretty good handle on narrative structure and characters, so he knew more going in than many folks. By the time we'd exchanged a few emails and done a phone pre-interview, I'm sure he had a pretty good sense of the story lines I might pursue. As a former stand-up comic, he's also used to "performing" a story—albeit in front of a live audience, not one person with a camera. Knowing that my end-product would be a mini-doc of under 4 minutes to be screened before a large crowd of about 15,000 people, my role was to be a gentle guide, digging for the key stories that would captivate and motivate this audience. My role was also to provide an engaged audience for Jeff. And in a way, that was tough. He had so many funny lines and asides, I had a hard time trying to laugh silently, so I wouldn't ruin his soundtrack. I had to let my whole body laugh, to give him some visual feedback, without actually cracking up. But our conversation primarily focused on more serious components of Jeff's life. The central turning point in the story arc linked back to some scenes in his childhood dealing with anti-Semitism in the neighborhood where he grew up. One story—of a swastika being carved onto his locker—was an essential one for the opening hook, connected to the later climax and turning point of the story where, as an adult, he becomes politically active.

Looking over Jeff's transcript, I can see that in an interview of an hour and a quarter, I only asked 12 questions, which isn't many. And some of these weren't truly new topics, but just probing a little further on a subject he had already begun: "But the little boy . . . tell me more about how he felt about that?" "You mentioned a detour from comedy. . ." This is what you are called to do in the dance of the interview: Encourage, guide, reveal.

As interviewer, you aren't leading. You are part of a duet. So while it's great to have questions, and lists or even scripts with possible answers, it's much more important to be engaged in the moment. Be present. Be a partner. If you've done your homework, you'll already

have a sense of what kind of dance this will be—a fluid waltz or an up-tempo jitterbug. Or perhaps it's a combination. Don't bring a sheath of intimidating notes. Even an experienced interviewee will look over at that and know you are an interrogator, not a partner in this process. Without stomping on toes or dragging your partner around on the dance floor, you can help to uncover an engaging story. When you do that, you will go beyond the soundbite, to the essence of the teller's story.

BEFORE YOU CONDUCT AN INTERVIEW

So how do you begin to prepare for an interview? Start from your pre-interview notes—remember those?—and reverse engineer questions to get a feel for how you might uncover key points or stories. I read everything I can about a person. Review all your questions, and see how and where each one might fit into a larger story arc. If it's helpful, sketch out the possible narrative arc on paper, starting with the key turning point or climax, and working backward. You may have a good sense of what your hook might be—that inkling, that moment which connects to the bigger central challenge. Or you may have to uncover the hook once you get into editing. If you are conducting multiple interviews on the same topic, consider three or four broader themes that can tie together these differing perspectives. The day of the shoot, I might have a piece of paper with a rough sketch of my potential story arc. I may also have some shooting boards—brief storyboards that remind me of the look and feel we are going for—special interview set-ups, and any special layouts I need to keep in mind, such as leaving room for vertical rather than horizontal on-screen ID for the speaker. But I will only look at these away from the interview subject. For a micro-doc with a tight time target such as 3 minutes or less, I might even have a rough shooting script, so I can quickly glance through any hoped-for soundbites just before I go into the interview, to be sure I'm asking questions that might elicit related answers. Such a document should never

CHAPTER 9
BEYOND THE SOUNDBITE

An interview is a duet, so keep technical discussions brief.

Credit: Amy DeLouise

preclude having the interview go in an exciting or unforeseen direction. A story plan, a shooting script, and shooting boards are simply tools to help me and anyone on my production team visualize where we're headed. Then it's time to turn your attention to 100 percent engagement in the on-camera conversation.

DURING THE INTERVIEW

Setting your Subject at Ease

It's vital to set your subject at ease. It will help you build rapport and trust—two essentials for a good interview. You'd be surprised how even experienced interview subjects can get nervous once the cameras and lights are set up around them. If you've done a

131

pre-interview, you will already be ahead of the game on this front. You'll have some conversation points to get your interviewee comfortable. Find a topic that makes them smile—vacation, kids, sports—while final sound and visual checks are going on in the background. Make sure that your subject understands this is an informal conversation. There are no "right answers." That said, if you are interviewing a CEO or a politician, they will have a handler and there will be a list of right answers floating around somewhere, guaranteed. It's even more important to put all those concerned at ease by telling them they will have a chance to refer to any notes or repeat any answers before you wrap up.

Another key to building rapport is maintaining eye contact and open body language. The minute you drop eye contact to refer to notes, you have altered your position from being a partner in a conversation to being a producer or director in charge of a shoot. This power shift will be noticed by your interview subject, and you will lose your natural rapport. The same goes for clutching your notebook or clipboard—this closed body language speaks volumes. If you must turn to speak with crew or executive producers on the set, try to minimize these interactions. I often work out signals in advance for reframing shots from wide to close, so I don't have to discuss this with my camera operator during the interview.

Dealing with the Unexpected

In any interview, there can be unpredicted moments and detours. Usually these are wonderful, genuine interactions between you and your subject. If you think the subject may cry, it's wise to put the prompting questions related to that topic later in the interview, in case they never recover emotionally. I've interviewed mothers whose babies have died—a heart-wrenching situation, and not a point in the interview you want to push through to get to some other, less consequential story line. You also want to avoid the shouted question over your head from the EP. Oh yes, I've had those, and they

rudely break the trust environment you have built with the subject. And now, your subject is looking around the room between your questions to see if anyone else they hadn't noticed before is going to ask one. If it's likely your EP or client will want to ask questions, try to vet them up front and before the interview. Discuss prior to rolling that you will pause at certain key points to offer a place for either the interviewee to add something, or for other team members to add their questions. Try to be crystal clear that you control the set. (Not the interviewee, but the environment around you both.) Your ability to keep distractions to a minimum will allow you to adapt if and when other surprises arise. But ideally, there is only one interviewer and one interviewee doing the dance together, so that the trust relationship offers an opening for the story to emerge.

Challenging Topics

One of the most challenging topics for an interview isn't trauma or dramatic life events, it's talking about a technical process. This is common for certain types of documentary; the medical documentary, for example, where a neurologist might talk about a new procedure for detecting Tourette's Syndrome in the brain. It is also common in what is termed "corporate video," which can mean anything from a federal agency video describing a new animal-tracking procedure to a corporate outreach piece explaining a new delivery system to customers. But even a process has a central challenge—a reason the new process was put into place—and this should be the central focus of your interview. What's more, a new process is often tied to broader societal issues or even international challenges, so that gives you even more fodder for giving the back-story to the challenge, and then the interview subject's role in the resolution.

Let's take the case of the federal agency video. For this project, the reason for focusing on animal-tracking procedures was an uptick in mad cow disease, and concerns from the agency and the public about how to improve food safety while also ensuring markets for

American farmers. That's a pretty big challenge to tackle, so if you are asking questions of multiple characters in the story—food-safety experts, cattle ranchers, distributors—you can build the case for the challenge, perhaps punctuated by some headlines, and then intercut the answers to build to a climax and resolution. In this particular instance, the agency went and did some quick hand-held interviews with farmers and cattle ranchers. Only one or two questions were needed to get at the key challenge and the ways to resolve it.

Interviews for Multi-Character Stories

This brings me to another approach to a story arc with interviews—letting different interviews tackle different parts of the arc. This is a common approach in long-form documentary, where you might have certain historical scholars weigh in on those parts of the story line with which they have expertise. But you can also use this approach in short-form pieces if you do your homework on who the most essential characters are—remember, you only want a few voices in a piece lasting 5 minutes or less. So for a challenging subject that you feel may not have enough drama to it, including different perspectives on building the challenge and resolution may actually help add some pacing and excitement to the piece. If you are conducting multiple interviews that you plan to intercut later, it's helpful to ask *a few of the same questions to each person*. That way, you can evoke key themes and tie the entire story together.

Talking Points and When to Avoid Them

In the world of corporate video or political content, people love talking points. It makes the handlers feel that they've done their job if they provide interviewees with talking points. From your perspective as an interviewer, talking points can disrupt your dance with the interviewee. It's like trying to dance with an invisible third person. So if you're put into a situation where your subject or their handler wants

or creates talking points, try to use themes rather than full sentences your interviewee will try to memorize.

Instead of this talking point:

- **We're excited to roll out the ABC shipping program and we think it's going to change how customers do business around the world.**

Try this:

- **Customer challenge: doing business around the world**

 - **Our solution: ABC shipping program.**

If you conduct the interview in the right way, you'll elicit the first sentence. But your subject won't look at a long list of these and think they've got to learn them all for the interview.

CREATING A STORY ARC WITH YOUR QUESTIONS

The beginning of an interview is rarely the beginning of your movie. First questions should be throw-aways, confidence-builders for your subject. Don't try to get the very essence of your show in the first few words. For one thing, the sound technician may not have perfect audio levels yet, because despite tests, people often change their level of volume once they get started. Your subject may also shift around to settle in, thus disturbing the shot. So wait. My only exception to this rule of not doing too much with the interview at the start is when I'm working with the very elderly or infirm. These folks may tire easily, or we may be interrupted by medical personnel, so I need to move quickly from the warm-up phase into my essential questions.

The Hook

Most real people do not speak in perfect soundbites. William Zinsser, in his seminal book for authors, *On Writing Well*, calls this "stumbling so aimlessly over the sands of language that they haven't completed a decent sentence" (2006, p.106). Oddly, this makes drawing out your story hook easier. That's because it is likely to come up early in the interview, as a mere story fragment. Don't panic. Seize this marvelous opportunity to reveal the tip of the iceberg of your central conflict or challenge. You will elicit the full story soon enough. So plan for this moment, and prepare yourself not to pounce when someone makes their first allusions to what got them involved in or concerned about the central story theme. You've got your hook, and you can come back for more details later in your interview.

Building Toward the Climax

When you're ready to delve into the full story, be sure to ask "why" and "how" questions. In Chapter 10, we'll talk about quick ways to assess the learning style of your interviewee to help you elicit strong answers. If there's a chance you will do a cut-down version of your interview for a montage, promo, or web video, be sure to elicit shorter versions of the central challenge. One way to do this is to use themes as the basis for questions. "How does the work of XYZ non-profit propel *social justice*?" "How does EFG company's expansion connect to its core vision about *innovation*?" By prompting with thematic cues, you can help elicit shorter, more thematic responses.

Once you've established a hook, and started your subject talking about the central themes of your interview, it's time to tackle the central challenge or climax. Generally I like to get to this at the mid-point of the interview. By then, the subject is warmed up, and we've built some rapport. If they were nervous, you would hope they've become a little more relaxed. Plus at this point I've got some context for the story, with descriptions of any other characters. But it's still

early in our conversation, so my subject isn't tired out. If the story is a very emotional one, then just telling it will start to tire out your storyteller. Be prepared that the interviewee may not be able to participate further. And be respectful of that boundary.

Moving Toward the Conclusion

To elicit conversation about the ending of the story, ask questions about how something got resolved. Ask process questions: "Walk me through what happened next, after you figured out who had committed the murder." In some instances, there is no resolution. You may be shooting a documentary about an ongoing problem such as childhood obesity or pollution. In this case, your conclusion questions don't need to elicit a full resolution of the issue, but rather some final thoughts of your main characters. Questions like:

- **What do you hope will be accomplished on this issue 10 years from now?**
- **What will that look like? How will it feel?**
- **What do you hope others will do when faced with this kind of discrimination?**
- **What good do you hope will come of your son's death?**
- **How do you envision this farmland will look a decade from now?**

Your goal is to get *big-picture answers* that will essentially narrate the closing scenes of the film or segment.

Wrapping Up

It's also extremely important to build a satisfying conclusion to the interview. I am not talking about the ending of the film, or the end of the story arc. The interviewee should simply feel good about the experience—even for an intense, emotional, or even confrontational

interview. Often a person will begin to feel insecure toward the end of the interview, when the adrenaline begins to wear off, and will want to redo an answer or two. That's okay. Give them a chance to rephrase, even if you know you already have it in the can or can edit the response easily. It's for the good of the relationship, now and in the future. You may need to go back to this person for photographs, documents, or other supporting visuals for the film. You may need them to make introductions to additional interviewees. Or you may need them to review some writing as a subject-matter expert as you refine the edit. The last thing you need is for them to change their minds about appearing on camera. Remember that the conclusion of the interview may not be, and in fact is unlikely to be, the conclusion of the production process.

When the End Isn't Really the End

Speaking of endings that aren't really endings, many people start to open up once they believe the interview to be over. I know some producers who even say "Cut," but tell the camera operator in advance not to cut. I don't feel too comfortable about this pretense. What I prefer to do is not say "Cut," but to relax my posture after "one last question." Then I wait a few beats to see if the interviewee wants to add anything. I may ask them if we missed anything, and again wait. If they feel it's gone well, I may continue chatting with them. Nine times out of ten, they will then begin to discuss a new topic we hadn't addressed earlier, and we can now capture this without any problem. Most of my DPs have worked with me for many years, and know how I approach the end of my interviews. If you have a team that doesn't know you well, be sure to establish exactly how you will end your interaction.

TIPS FOR GETTING GREAT INTERVIEWS
- Do be respectful of your interviewee as a partner in storytelling.
- Don't interrupt too often. Guide gently and redirect when necessary.
- Do always offer water. A scratchy throat can kill your best take. And taking a moment to sip water can refocus a tired interviewee's attention.
- Don't bring up emotional subjects unless you are prepared to be patient, and know that the interview may come to an end soon after.
- Do hide unnecessary equipment from sight, and sometimes people, too.
- Don't bring more cameras and gear than necessary.

INTERVIEW DON'TS

Panicked producers often start throwing in extra questions at the end of a long and grueling interview. They are second-guessing what they have. Believe me, I've done it. In the worst instances, you may even be tempted to return to the central story challenge. Don't. Unless you had sound or camera issues, retreading this story will not be useful. It is almost never as good the second time around. And if you damage your relationship with the subject by making them feel they are repeating their entire interview, you will miss opportunities to gather good b-roll or other assets like photographs. Not to mention busting your budget by going over scheduled time. If you really feel you may not have nailed down the central story theme, help your subject recap by asking, "What's the *one thing* you think people should know about X?" The "one thing" trick tends to make people observe in a big-picture way that will be helpful later, in the edit room.

WHEN TO GATHER INTERVIEW B-ROLL

One big question that often arises regarding interviews is whether to shoot b-roll of the interview subject before or after you've conducted the interview. It depends. Sometimes shooting b-roll offers an easy way to develop better rapport with an interview subject before you sit down for a long conversation on camera. Sometimes working with your crew for b-roll will tire out an interview subject, so they are less fresh for your conversation. You need to gauge their personality, their tolerance for the camera, and also be aware of what is going on for them the day you arrive.

Often, I'll schedule just one or two shots on my wish list to get the day going. Then I will conduct the interview, leaving time for additional b-roll afterward. If you shoot all your supplemental footage prior to the interview, you run the risk of not capturing some moment

that would help depict a topic in the interview. If you shoot it all later, you run the risk of not building a good trust relationship between the subject and crew, and giving the subject a little time to get used to everyone before the laser-focused experience of an interview. So for me, splitting the b-roll shoot-up before and after the interview often works best.

CHAPTER 10

CHALLENGING INTERVIEWS AND ON-CAMERA SUBJECTS

Andy Collins

IN YOUR JOURNEY AS a producer/director working with real people, you will come across common challenges of the non-fiction environment. Sometimes the subject matter itself will pose the problem. Other times, you'll face difficult personalities. Or you will need to overcome a language or cultural barrier with your subjects. The categories in this chapter are some of the most common challenges I've come across working with reality on camera, along with some potential solutions.

INTERVIEWING CHILDREN

Where I live in the Washington, DC area, an interview question rarely gets a yes or no answer. Children are the opposite of politicians. They generally give straightforward, succinct answers. Young children are not likely to "read between the lines" of a question. So if you are producing a story about the role of group learning in education, and you ask a 3rd Grader, "Do you like to work in groups in your class?"

When interviewing a child, sit on the same level if you can.
Credit: Courtesy of RHED Pixel.

143

they are likely to say simply "No" or "Yes." If you ask, "What kind of groups do you like to work in best?" they are still likely to give you an unsatisfactory response in terms of your storytelling. One thing we know about children is that they are highly kinesthetic learners. So you'll have more success if you ask a child to show you *how* something works or happens. "Show me how your tables are set up in your classroom . . . who sits where?" The physical space for the shoot matters even more for children than for adults. Interviewing children in a familiar space such as a home, rather than an unfamiliar place like a conference room or studio, generally nets a better story result. If you have to use a non-child-friendly environment, do your best to make it familiar, by bringing the child in early and introducing him or her to everyone on the crew, and answering any questions they might want to ask about the equipment. With young children—say 7 years old and under—we then play "the invisible game." All the crew we just met have disappeared. It's just the two of us. Kids are much better than grown-ups at pretending there are no crew to distract them. And as digital natives, they are not concerned about the camera either. When you join in the invisible game and enter the world of a child, you start to have fun. Now you are on the right footing for a good interview.

Parents or guardians are a natural part of the equation with children. Generally they are going to want to be in the room during a shoot. The child will naturally look to a parent for cues and approval between takes, or even during them. Set up your space so that parents can see a monitor, and easily see and hear what's going on, but be outside the peripheral vision of their child. You want a natural ally, but not a distraction.

TRAUMATIZED SUBJECTS

It's not uncommon when dealing with documentary subjects to interview people who have faced a personal trauma. I have interviewed

mothers who have lost a child to SIDS (crib or cot death) and children who lost a parent on 9/11. I've interviewed a teenager living with AIDS, and a family on the verge of homelessness. Whatever the situation, you must first be a human being, and only second a producer and director. Make the interview environment as comfortable as possible. Keep equipment to a minimum, which is thankfully easy these days with small-profile cameras such as the Canon C series. Keep crews small, and keep any non-essential folks out of the room during takes. Run a cable into a hallway with a monitor for personnel such as a lighting director or makeup artist or executive producer. Your sound person will probably be the first person besides you interacting with your subject. Be sure to brief them in advance on the situation and any sensitive subjects that might come up.

Most importantly, discuss boundaries in advance with your subject. If you are willing, let them know you can give them veto power over anything they would prefer to leave out later. I know some people think that this is giving your on-camera subject too much editorial discretion. For adversarial news interviews and investigative documentaries, that could be the case. But for a traumatized person, it is important to offer this power because it reinforces the give-and-take relationship that allows your subject to be honest and comfortable telling a difficult story. And after all, telling the stories of real people is our great privilege, and we can't forget it.

NERVOUS AND INEXPERIENCED SUBJECTS

Lots of people get nervous in front of cameras. Even seasoned speakers can experience panic when the lights go on. Having a stylist on your crew can work wonders by providing a confidence booster with a friendly face before you begin interacting directly with your subject. An expert stylist knows when to intervene, and how to wipe that drop of sweat without making the person feel self-conscious. If you have to get up and do that, you'll make it very obvious and create

a potentially uncomfortable situation that might affect the interview substance. But if you can't have a stylist on board, then try to have some personal interactions at the start of the interview to diffuse the tension. If you've done your homework, you already know about family members, upcoming vacation plans, and other topics that can make a nervous person smile and forget for a moment what's going on around them. Generally, nervous people get worse, not better, during the course of an interview or other on-camera appearance. Be prepared to keep your questions to a minimum. Offer water and short breaks when needed. And give your most encouraging smiles and nods. Visual cues are your most important tool in providing emotional support.

VIPS, CELEBRITIES, AND EXPERTS

Some of the most nervous and challenging subjects I've worked with on camera are celebrities, CEOs, and subject-matter experts. These are the very people you'd think would be fairly comfortable in front of cameras. Yet it's worth remembering that not every celebrity loves cameras. The reasons can vary widely, and it's useful if you can do your homework to be prepared. For example, I once interviewed a brilliant scientist who admitted to me up front that he had such terrible Attention Deficit Hyperactivity Disorder (ADHD)—which had eventually led him to a career in science to unlock the genetic secrets of the human condition—that he was unlikely to stay focused for more than 5 minutes at a time. He was right. I had to let him get up and check on experiments and talk to colleagues in between every question. A brilliant conductor was another fascinating interview subject. Having worked with her for many years, the crew and I were not surprised that she almost directed our production from her seat. I once worked with a Very Famous TV Personality whose name shall not be included here. That's because her on-screen bouncy persona was a far cry from her real approach, which was difficult and anxious. Her assistant was equally challenging. Such is life. As a

director or producer, you need to be ready for everything. Your best weapon is knowledge. Your second is patience. And for challenging VIPs, the crew needs to be 100 percent on their toes, with no chit-chat. Everyone needs to exude the confidence that you will make this person look and sound their absolute best.

Sometimes VIPs have extra support staff around them who cause them to be distracted. I had the misfortune to coach a brilliant CEO for an on-camera appearance during a time when the company had retained some brand consultants to work with her. They kept shouting instructions to her over my head after each take. It was clear that they had no real experience of directing, and were simply trying to prove their value. I finally had to take one of them aside and let them know that I was more than happy to let him direct the shoot, but only one of us could do it. I kept the job.

LANGUAGE AND CULTURAL BARRIERS

When someone doesn't think in your language, it changes the dynamic of an interview. Depending on their fluency in the language of the interview, which in my case is English, this person may be double translating—that is, translating your question, then thinking of their answer in their native tongue, and then translating it back to you. This takes time. Be patient. Don't jump into pauses to ask another question. Your best response may be emerging, but more slowly than you realize. Use body language to encourage them, by leaning gently toward your interviewee. If it feels natural to you, tilt your head as you listen. Psychologists (and Charles Darwin, if he were still around) would tell you that tilting the head to one side inspires trust, because it exposes your jugular vein and indicates submission. I've watched footage of myself conducting interviews and was astonished to find that I do this subconsciously, and most often with non-English speakers. It's a natural instinct to encourage the speaker. If it works for you, go with it.

WORKING WITH TRANSLATORS

If your pre-interview reveals a true language barrier, then you may need to work with a translator. The choice to use a translator is a tricky one. In some cases, the decision may not even be yours to make (i.e., an ambassador who always travels with her translator). If you do have a choice, consider whether the heart of the story could be changed by the interpreter. My preference is always to have a direct connection with my subject, which is lost when a translator is introduced into the equation. Also consider a thick accent, and how it might impede the audience's ability to enjoy and understand your production.

Subtitles are often an easy solution. And because you've already followed the steps (in Chapters 1 and 2) for getting interview transcripts, you'll have an easy time of outputting subtitles if needed. If an interviewee is really difficult to follow, my preference is to have a translated interview narrated by a voice of similar timbre, and the same gender. I don't want viewers to lose eye contact with the face and constantly be looking away from the footage to read titles. For one project, I interviewed a group of Christian, Jewish, and Muslim teenagers from Jerusalem and the West Bank. Throughout the interviews, my sense was that they were all quite articulate in English and easy for me and the crew to understand. Once in a while during editing, my editor and I came across a tricky word, but the context seemed to make those sentences accessible. But when we tested the film in multiple markets, audiences in the US Midwest asked for subtitles. And they may have just been the only ones being honest with us. Ultimately you want the story to be compelling to as many viewers as possible, so stay flexible. And flexible is probably the most appropriate word with which to end this chapter.

CHAPTER 11

EDITING WORKFLOW STRATEGIES

Andy Collins

EDITORS ARE STORYTELLERS. AND there's nothing worse for an editor than to receive a drive of mystery footage with no clues as to what story lies within. When real people play a role in a story, scenes are not typically precisely storyboarded. So building the story can bring some special challenges to the traditional production-to-post workflow. It's critical that you plan to communicate early on with your post-production team and use every tool at your disposal to ensure a smooth transition to post-production. As Sheila Curran Bernard says so pithily in her book *Documentary Storytelling* (2015):

> *Films don't go over budget because you paid a sound guy too much and put the crew in a hotel for an extra day. They go over budget because people waste two months of editorial time figuring out what the story is.*
> (Bernard, 2015; Chapter 3, p. 52)

Luckily, there are myriad tools and strategies at your disposal to help you and your editor become partners in storytelling rather than scavengers hunting for missing shots.

THE PRODUCER'S ROLE IN THE EDIT ROOM

I consider the editorial process to be a team event. The editor is the team captain, and brings his or her vision and skills to the story. As producer, I'm the team manager, so I have to keep the big picture in mind—deadlines, budgets, personalities, and why we're doing this story. But I need to let the editor bring something new to the creative process. An editor often brings a dose of reality to the story development process. They will say that a particular shot is just not working. Whereas we producers can often fall in love with a shot because we know just how much effort it took to make it happen.

To ensure the edit goes smoothly, I typically send my footage well in advance of the edit, so the editor has time to screen everything and get their own sense of the characters and story. I also send a paper edit, which we'll describe in more detail later in this chapter. Often, the editor will work alone for several days or a week before I come in to review and discuss the story. Sometimes, I'll sit at a "producer desk" in the back of the room with my headset on so I can pick music selections or find a better soundbite or piece of b-roll, while the editor works on a segment. Usually, I'm making editing script changes in real time, so that we always have a paper script that reflects the story to date. This is essential to share with any executive producers or clients who need to review our progress. With projects that require multiple shoot days and locations, the rough cutting process might start while we're still in production. On other projects, we might wait until all assets—including stock or archival images—are in hand. In most cases, there are still some assets to be acquired while the post-production process begins. The most important component of a good edit process for me is the give and take between producer and editor to build the story. Great editors have a way of re-ordering shots, or pulling in little clips for transitions, that make all the difference in delivering the story in a more meaningful way.

Communicating Story Notes

In the real world, every shot you hoped for on your initial scene list may not have been recorded. Interviews might have run in new directions. Locations may have changed at the last minute. Two people re-enacting a scene offered wonderful and surprising moments, but not the ones you had on your shot list. That's all part of the fun. And one of the first steps in the post-production workflow is for you to review what scenes you actually captured, and ensure that the editor has that list. This may sound basic, but editors will thank you for delivering a clear scene list with every drive of field footage.

Audio is also absolutely critical. And just like the visual scenes in your film, it may have unfolded differently from what was planned. Sounds like sirens, dogs barking, or people running the copier may have intruded on important scenes. Or a baby crying may have been inadvertently captured, and will make a wonderful sound-up moment in the film. Take copious sound notes, and deliver them along with scene notes prior to editing. I would hope that you have recorded room tone at every changing environment, and even more than once in long interviews with a lot of background noise. And if your characters have any dialogue, convey which takes worked and which ones didn't *for audio*, not just picture, in your scene notes.

Note-Taking Tools

There are lots of options for conveying notes to an editor. I tend to use a combination of typed field notes and hand-written script-supervisor-style notes with take numbers on my shooting script, depending on the type of production I'm directing. If you want to go all-digital, ScriptE™ offers comprehensive script supervisor software for on-set note-taking and delivery to your editor. At $600 ($300 for the iPad version; $150 for the student version), this might be a budget-buster for some short non-fiction projects. Notes in the Adobe Live Logger app or Google Docs can be just as handy. You simply need to ensure that your editor understands what the best takes are, especially for audio, and whether or not someone went "off-script" if there is dialogue or direct-to-camera content. Conveying this information will increase the speed of the edit and any sound design and audio mixing that happens afterward. On-set changes to teleprompter copy occur all the time, too, and you want to avoid having your editor fishing around for audio that doesn't exist. Always bring an extra thumb drive along, and export a final text file from the prompter system. Include this file along with any other notes documents such as interview transcripts or your editing script when you hand off your shoot footage.

Shooting Script Marked for Edit

Scene	Video	Audio
1.	Workplace montage–all locations, diversity of job types and people	VO: Throughout DEF Company, you are working hard every day to deliver on our brand promise.
2.	Host walking toward camera, camera tracking back through DEF hallway, with cubicles of employees on either side; stops, turns.	HOST ON CAMERA: But what about our promise to each other? How do we create a working environment in which we all feel respected? One in which we are each individuals, but also part of a team?
3.	Pick up host turning to Second camera angle. We see people moving and working together in the background.	HOST TURNS: You decided that we needed more accountability to one another to create a supportive and team-oriented workplace. Out of our Transforming the Workplace process, you created new standards for everyone at DEF Company.

Using Slates

Many times, slates save the day in the edit room. First, finding a slate visually as you scrub through footage is much easier than stopping and starting to listen for new takes. Slates in combination with field notes provide key field information for your edit hand-off, and ensure syncing works for multiple camera angles. You can use a "smart slate," which includes synced timecode, or a "dumb slate" for which the sticks can be slammed together to create an audio sync point, and still includes all the important scene, date, and take information. There are also several iPad slate apps available. My experience has been that unless you are syncing a massive number of cameras, a dumb slate works well for most situations. Also, it never runs out of batteries during a long shoot day, and the physical sticks are loud enough to hear over most background audio. (If you are looking for handy tips on slating, this post is helpful: http://nofilmschool.com/2015/05/how-slate-pro-plus-how-you-definitely-shouldnt-slate-ever.)

Hand off audio notes with footage for a smoother edit.

Credit: Amy DeLouise.

MAPPING OUT YOUR STORY

Working with Transcripts

Transcripts are not optional. They are an invaluable tool for storytelling. And transcripts don't just help in the immediate editing process, but allow for crucial time saved during future re-versioning or captioning. Most people think of using transcripts for long interviews. But even for shorter interviews or "dialogue," they make sense. That's because human-generated transcripts are generally quite accurate, are inexpensive, and keep you from having to scrub through footage looking for a particular word or phrase. With certain digital tools, they can even be synced with your footage to help you find just the right take. As a seasoned documentary editor (*Frontline*, among other shows), Steve Audette says (interview, October 12, 2015), "Transcripts are key. That story needs to be transcribed, so you can find the most effective bites from interviews. It's one of the fundamental cornerstones of documentary storytelling." Even in non-documentary formats, such as re-enactments or reality TV, transcripts are essential. Since you are working with real people, they are not likely to deliver their "lines" the same way each time, and finding your story line will be much simplified by a transcription of what actually was recorded in the field. Describing her work (interview, February 13, 2015) that begins with reviewing transcripts for shows such as *Hoarders* and *Diggers*, experienced Supervising Writer/Producer Lisa Feit says, "I must see every color I have before I start painting."

I usually get transcripts done immediately following the shoot, and there are two ways to hand off the files. If you aren't in a rush, you could output audio from your interview files once you have them ingested into your edit system. Most transcription services will work from an mp3 or WAV file. While mp3 audio file sizes are smaller, today's upload speeds are fast enough to allow you also to upload WAV files to most transcription services' websites or designated FTPs. If you want timecoded transcripts, the fee is slightly higher, but

this gives you a handy runtime in the margin. You can also approximate timecode by giving the transcriber the starting timecode for each interview or segment of audio. They have run clocks which can approximate the timecode pretty closely and insert it throughout your transcript. Often this is good enough for the purposes of finding a soundbite.

For rush projects, you may want to record back-up audio files that can be sent for transcription as soon as your shoot wraps. In the field, we are usually recording high-quality audio through a mixer which includes metadata like timecode, frame rate, sample rate, bit rate, and track info. Timecode and track info—like the name of your interviewee/speaker—is very handy for transcripts! Recorders such as Sound Devices 744T, 788T, 664, and 633, and the Zaxcom Nomad and Maxx are the ones you'll frequently see in the field and they all have these capabilities. The Sound Devices 552 will *read* a timecode signal from another device (such as the camera) and will stamp the start timecode on its audio recording. Smaller and cheaper recorders such as the Tascam DR-05 and DR-07, the Zoom H4n and the newer H5 and H6 don't have any timecode capabilities. For these, timecode would need to be recorded onto one of the audio tracks. Even if you are recording to the camera, it's always great to have a high-quality audio back-up file using one of these devices, so having a file handy for transcripts is a bonus. If you want to do your own transcripts, Wave Agent from Sound Devices will allow you to read timecode from field audio files (www.sounddevices.com/support/downloads/wave-agent).

Paper Edits and Best Takes

Once you've got your transcriptions back, the next step is to incorporate that information into your edit workflow. Ideally, you already had a shooting script, and you are now updating it into a post-production blueprint that is your editing script. When you do this "paper edit," you can see how the story arc is or isn't working before

you burn valuable time editing. If you are using narration, this is the time to determine any narration that will be needed to provide "glue" between interview or re-enactment segments. If you are doing an interview-based piece, you'll want to include timecoded "in" and "out" points for the soundbites you want to use, plus any alternate soundbites you have available if something doesn't work. I like to use a slash / to indicate a place where I think a bite needs to be edited or "pulled up" so that it is more concise. So, the original soundbite might be: "In the book, I want to explain all about the editorial workflow for real-people projects, which is, um, including, the um process of how to lay out a paper edit." And my proposal for how to edit the soundbite looks like this: "/I want to explain/ all about the editorial workflow /of how to lay out a paper edit." If I have timecoded transcripts, all the better; I can include timecode information along with my suggested edits.

I'm a big fan of color-coding. So when I'm reviewing my transcripts, I typically highlight "best bites" in a special color, so my editor knows that I think these play a vital role in the storyline, even if I'm not sure what order they need to be in yet. Sometimes I will assign a few other colors—one for bites that I think may still work, but aren't my favorites, and one for those that could work in a shorter version or a highlights piece. Often, I'll ask my editor to string out our favorite takes on paper into a "best of" timeline that we can review together to see which ones resonate the most with us on screen. This gives us a mutually agreed-upon resource for soundbites to drop into the main story timeline when needed.

Tools for Syncing Scripts and Transcripts

Automated syncing for transcripts and scripts appears to be a good news, bad news story. The technology exists for voice recognition and syncing of matching printed text. But the economic incentive for integrating this with editing software doesn't seem to be keeping pace. So at the time of publication, neither Avid nor Adobe were

offering full automating capabilities. Avid's handy ScriptSync™, which relies on audio recognition technology from Nexidia, was not included with Avid's Media Composer 8, but the companies are in negotiations, and industry watchers are hopeful that these automated capabilities will return with later versions. Editors have told me it is still possible to "manually" synchronize key bites—that is, by dragging and dropping shots where someone is speaking key words onto those same lines of a transcript imported into the project, thus maintaining a text-based link to that audio throughout your editing process. Steve Audette offers two good online tutorials for using these tools: https://vimeo.com/17502817 and https://vimeo.com/95543071.

Earlier versions of Adobe's Premiere Pro video editing software had an audio recognition feature that was not working as planned, so it

Editor Isabel Yanes keeps track of best takes using ScriptSync™ for Avid.

Credit: Photo by Zoe Taylor. Special thanks to Cariann Saunders.

has since been removed. However Adobe editing expert, director, and author Maxim Jago tells me that this feature still exists in CS6, which comes with Creative Cloud membership.

> **With Premiere Pro CS6 installed, you can point the script analysis at a script, and rather than guessing at the words, the script will be used as a reference . . . The result is time-based dialogue embedded in the metadata for the media files (which is incredibly useful). When you import those media files into the new version of Premiere Pro, the dialogue will still be there and is usable for editing purposes.**
> (Jago, email exchanges, September 28, 2015)

Adobe also lets you install (free) other languages and accents other than English. But the real key is being able to import your script, which will then allow you to match those phrases and find your edit points. For the time being, Adobe works best with an Adobe Story ASTX file or a text document.

For Final Cut Pro X fans, the system relies on keyword ranges —metadata applied to part or all of the clips. If you have your producer-highlighted transcripts in hand, you can find those keywords easily in order to set up your tagging system for clips. So "If someone talks about a 1962 Civil Rights protest in a Memphis church, that footage can be assigned the '1962' 'Civil Rights' 'Protest' 'Memphis' and 'Church' keywords and appear in all those lists—known as Keyword Collections," explains Final Cut Pro X editor and plugin maker Alex Gollner. Third-party tools like the Lumberjack System (http://lumberjacksystem.com/) take advantage of the FCPX keyword system and go one better, by helping you log keywords associated with time-of-day time ranges while you're shooting in the field, to get a jump on creating keyword-driven stringouts. It can also align time-stamped

REAL PEOPLE ON CAMERA

transcripts with the time ranges in the media files so that you can take advantage of FCPX's powerful "find" facility to locate the soundbite you need.

Lumberjack System Transcript Mode in action.

Credit: Courtesy Lumberjack System.

Regardless of your editing platform, take advantage of getting interviews transcribed and use keyword and tagging systems integral to, or as add-ons to, your editing software. Please stop scrubbing through footage looking for soundbites! I find these methods to be more accurate and cost-effective, with very fast turnaround. Then I build the editing script by replacing my fantasy soundbites with actual soundbites from my transcripts. Whether you are digitally importing this script, or simply working from a paper copy, it will simplify finding your "in" and "out" points of soundbites and save enormous amounts of time and money as you are editing your story.

MANAGING STOCK OR ARCHIVAL ASSETS

We've talked extensively about how to handle shot coverage for re-enactments and documentary-style productions to help cover inconsistencies (Chapters 1 and 8), jump-cuts (Chapter 2), and scene transitions (Chapters 2 and 4). These shots will be critical to making your edit complete. For your edit, you will need to assess how well these scenes propel your story. You may need to supplement your primary original footage with archival images—either photos and family footage from your subjects, or materials that you research from stock or historical image archives. Let's say you are working on a project about an entrepreneur/philanthropist who grew up in the 1930s. Ideally, your subject has provided you with a large quantity of source material. But for a segment about his growing up, he may not have many images available. You want to convey the circumstances of his childhood, and his entrepreneurial spirit even at a young age, because this important background connects to your story arc climax about his philanthropic giving. You will need to get creative. You may decide to purchase stock imagery of children in the Depression. You might even get lucky and find photos of children from the city where he grew up. Or you could merge two images together—one of generic children of the time, the other of a streetscape from the subject's home town. Generic archival materials, when properly adapted, can be very effective for supporting a story. (I know one brilliant photo colorist specializing in historical imagery who goes to estate sales hunting for items she can use for just such a purpose.) Once you've decided which images to use, you'll need to make sure these supplemental images are tagged clearly for the edit, and that you identify any licensing restrictions on stock images. It's a good idea to identify your archival materials both in an asset list for hand-off to your editor or post-production manager, as well as in an editing script. Save any such documents on the same drive as the source media.

Stock assets usually involve licenses. So editing with the images or audio is only part of the work. As a producer, you need to be sure

Sample Asset List for Edit

ID Info	Description	Source	Credits or Copyright Info
ASSETS IN HAND NOW			
61-231_TrumanPortrait	President Truman portrait	Courtesy of Harry S. Truman Library	Public Domain U. S. Navy, Frank Gatteri
73-2067_TrumanRoseGarden	President Truman in the Rose Garden	Courtesy of Harry S. Truman Library	Public Domain National Park Service, Abbie Rowe
61-116-14_YoungHarryTruman	Young Harry Truman	Courtesy of Harry S. Truman Library	Copyright Unknown
TrumanWHReno_1	Renovation of the White House done under Truman Administration	Courtesy of White House Historical Association	Copyright Unknown
Archival WH tour footage	1960s tour	Courtesy JFK Library	White House Photographer
Steadicam WH footage (ours)	Our Steadicam shoot	Internal	Location release on file
Shot 10/20/15 Best bites highlighted in Transcript: Simpson_102015	Bess Simpson, Historian	Internal	Release on file

that folders are clearly marked so your editor knows if these contain low-resolution images For Placement Only (unlicensed, for approval purposes only). Or they might contain high-resolution images that are already licensed for use. Retain all original ID numbers in filenames, even if you add your own, so that images can be tracked back to licenses. Save licenses into your project Documents folder using the PDF/A format, which is an ISO-standardized version of the Portable Document Format (PDF) that should be more accessible to all of us in the future. If there are any special agreements or limitations on the material, note them in an additional document. For example, if the images or videos are personal and belong to your subjects, be clear about whether or not they can be used for any future project or only this one. Editors often reuse materials from previous projects.

Building an asset list simplifies the edit process.

Credit: Amy DeLouise.

FUTURE-PROOFING

In the world of reality production, particularly in documentary and advocacy media, we are always trying to reuse and recycle whenever possible. There may be archival images you acquired for one show that you might need for another one. Or you have interview out-takes from a documentary that work beautifully for the web content that appears with the program. This makes future-proofing an even bigger challenge than it already is. We can't simply put a finished show on a back-up drive and walk away. Nor can we acquire every project in 5K, since that may not be realistic for your budget or your storage capacity for long-form content. However challenging it may be, future-proofing your production is a critical part of your story process, and it shouldn't wait until the end. In truth, it should be one of the first conversations you have. Are we going to want some of this footage for a future project? Do we need to acquire licenses with that in mind? Should we conduct interviews without references to certain dates? Do we need to be sure that direct-to-camera reads or scenario re-enactments don't include individuals who are soon rotating out of those jobs? Because real-people shows are often working on tighter budgets than some fiction programs, we producers need to consider our future needs up front. Some of the actions you can take for future-proofing are easy steps:

1. Make sure you save a textless version of your show, without lower thirds titles.
2. Split audio tracks, in case you need to return to a project for new versions or revisions.
3. Save copies of all sound and image licenses with the source media, as well as in your Documents folder in the project. Make sure that any "expiration dates" of releases for interviews, music licenses, or visual licenses are spelled out.
4. Tag alternate reads without dates or other content that might need to be revised later.

5. Back up to write-once optical discs whenever possible, in addition to hard drive back-up. Redundancy is critical. And remember that drives that don't spin, don't function after long spells sitting on a shelf.

Do your best to future-proof. But remember that there is no digital file format we are using today that we know for sure will be accessible to us decades into the future. Film, anyone?

CHAPTER 12

MANAGING CLIENT RELATIONSHIPS AND APPROVALS

Andy Collins

MANAGING CREATIVE RELATIONSHIPS AND the related approvals process remains a defining task for the producer. Much of this work is common to all genres, not just non-fiction. Still, working in reality often requires more leaps of faith, more managing of expectations, and deft navigation through creative workflows largely due to the unique issues involved with using non-professionals on camera. In genres such as product testimonials, there are the added challenges of managing approvals with multiple creative teams such as a production company, an advertising agency, and an in-house marketing group. In other non-fiction genres, such as advocacy or corporate, there may be layers of organizational leadership engaged in the creative process at different approval points. In the documentary genre, too, there can be a multitude of players, including the originating producer's company, various co-producers, funders, and distributors. Everyone needs to be brought into the action at some point. And everyone with skin in the game is a relationship to be cultivated. And yet you, the producer (and perhaps also the director and camera operator or editor) are trying to do all of this management work and still get your creative vision achieved. How can you do it?! Let's break down some key elements of the process.

DEFINE THE MISSION

It's helpful to begin with a mission. Every project should have one. And let's hope it also ties into your personal mission, whether that is developing a particular skill set for your portfolio, working in a special subject matter of interest, or building relationships in a certain genre of production. My personal passion for issue-related advocacy dovetails with my work as a storyteller for non-profit organizations. Both the organizations that distribute my work, and their internal staff who act as executive producers on our productions, tend to have clear personal and professional connections to the organization's mission and the people they serve. Of course, that doesn't mean that when we are all working on deadline, we don't occasionally get

derailed from our central thesis. So it's helpful to have that already defined at the outset, preferably in a concise creative brief. What is the purpose of this production? How will it further the mission of the organization (or the cable network or the community that is the audience)? What will the viewers think, feel, and ultimately do as a result of this show? This litmus test also works for corporate productions for marketing or training. And it can be adapted for scripted television reality shows. What role does this episode play in the series? What characters will we reveal? What character interactions and plotlines will be advanced? What themes are we revealing? And for the series more broadly, what niche does this show fill for our audience that they can't find anywhere else?

For documentary, the mission-related questions are remarkably similar. Why are we producing this documentary, apart from the passion we have personally for the subject? Is it particularly relevant to current events but told through a new creative approach, such as Iva Radivojevic's powerful film *Evaporating Borders* about the migrant experience? Or maybe the film reveals an unknown story, as in Karen Whitehead's *Her Aim Is True,* a film about rock photographer Jini Dellaccio. Is the film revealing historical events through a new lens, as does *The Law in These Parts* about Gaza, produced by Liran Atzmor and B. Z. Goldberg? Or perhaps the film's mission is to reveal a cultural phenomenon in a new context, as with Crystal Moselle's documentary about a group of home-schooled boys, *The Wolfpack*. These are just some examples of how the mission undergirds the project. In other words, the "why."

If you had to write a proposal for your project, then you have already presented the "why," and should be able to derive a brief mission statement for your production from this document. Simon Sinek offers a great TED talk, "Start with Why" (www.youtube.com/watch?t=1&v=sioZd3AxmnE) on this topic of getting to the why, rather than the what. While his talk is aimed at corporate leadership, it's helpful to any filmmaker trying to drill down into the mission of her story. Once you've defined the why of your production, and got agreement

from all the decision-makers involved, you can now cleverly use this mission touchstone at every decision point of the production. Whenever folks—or you—are overworked, tired, or just unfocused in a creative meeting, it's helpful to bring up the "why" and connect decisions to it. Script revisions, casting decisions, whether a scene should be in or out in another draft of the edit—all of these decisions can be guided by your overarching mission statement. See Appendix A for a Creative Brief template you can use.

SET EXPECTATIONS

For all personalities, it's always crucial to set expectations early in the project. We talked in Chapter 2 about flagging areas where certain variables can impact financial outcomes. There are similar flags you can throw for creative decisions. "If we make this change to the opening sequence, we miss introducing this key character, so we will need to shoot some more material in order to do that later in the show." I try my best to create three documents that help to manage expectations on every project: the creative brief, the concept storyboard, and the script. Whenever I try to get away without one of these, because I think everyone's on the same page, I always regret not having it.

CONNECT TO STRATEGY

Deeply connected to the "why" of any organization, whether it is a network, YouTube, or a non-profit, is their strategy. Specifically, most organizations are operating under a strategic plan, and whether you realize it or not, your project fits into it somewhere. The more senior the decision-maker reviewing your production, the more connected their work is to delivering on key goals of the strategic plan. Knowing the levers that drive these decision-makers helps you understand

Sample Creative Brief

> **Creative Brief–A Song in My Heart: Italians and American Music**
>
> **Prepared by: Amy DeLouise, Writer/Director/Producer**
>
> 1. BACKGROUND
>
> *Who is our audience?* A general museum audience. Viewers may love music and history, but not know about the history and influence of Italian musicians in America.
>
> *What do they already know about our subject?* This general audience likely is familiar with famous Italian-American performers like Frank Sinatra. But they may know little or nothing about the musicians in the generations who preceded him—those who came to the US from Italy and played in bands and orchestras here during the 1700s and 1800s.
>
> *What misconceptions or misinformation might they have about it?* They may have only a sense of individual musicians and their contributions, and not the history of European, and specifically Italian, musical training that influenced American compositions and performances.
>
> What do we want them to *feel* about the subject? Pride in the multi-faceted history of American music. Pride in what immigrants bring to America.
>
> What do we want them to *do* about it? Support the arts, and be more open to the positive influences of immigration on American society and culture.
>
> 2. CREATIVE
>
> **What is the stylistic approach best suited to our content and audience?** This is a mini-documentary for a museum exhibit with a twist—the historical musical compositions, archival clips and performances will be augmented by modern band members and musicians recreating certain sounds and segments in a modern studio setting. These same individuals will speak to the styles and influences on their own musical development in interviews both intimate and informal. Additional material is available to the museum attendee who wants to click on an individual artist for more footage/information.
>
> **What other creative elements or resources should be considered?** Archival footage and recordings.
>
> **What existing branding requirements exist?** None. Just needs to be in keeping with the tone and style of the exhibit.
>
> **What other platforms are contemplated?** A version will be branded and live on the museum's website in addition to outtakes of artist interviews.
>
> 3. TEAM
>
> **Who are the internal team on this project?** Writer/Producer/Director Amy DeLouise and lead researcher Christine Bader. Speaking to several DPs.
>
> **Who are the external team?** Exhibit curator, exhibit designer, exhibit production team
>
> **Who is the final decision-maker?** DeLouise and the curator of the exhibit

A creative brief offers a quick overview of a production.

Credit: Amy DeLouise.

some of their thinking about your film or show. I'm not suggesting you require a copy of the strategic plan at your first creative meeting. But there are often major clues to the big-picture goals—sometimes spelled out right on the organization's website—that will help you understand the vision. And you can always ask about "the larger strategy" for the network/non-profit/company and where your project fits into it. (And if you've already produced your documentary and are pitching it, then knowing where it fits into the larger vision for your dream distributor is definitely part of your homework for the pitch.) When you consider these underpinnings, you can get yourself out of a defensive posture when faced with a list of seemingly crazy changes to scripts or edits ("Cut out this entire scene.") and become more strategic in your response ("I understand you've been moving away from content on national parks, so maybe the way we can adjust this transition in the rough cut is to use the dialogue from the scene in the car instead of the walking shot from Yosemite."). By understanding the big picture, you move away from being "the person we have to deal with to get our changes made" to being a problem-solver. And everyone loves a problem-solver.

MANAGE REVIEWS

Creating a story with and about real people is a process. Nothing is cut and dried, even in a "scripted reality" show. Figuring out when to include decision-makers in an edit review can be tough. My general rule of thumb is not to invite review until we have reached a "fine cut" stage. But there are many exceptions to that rule. One is on a show where we are still hammering out the characters and story line. The executive producer may come in and listen to a string-out of just audio for interview sequences, to see if our story arc makes sense before we start cutting in the b-roll. This process works well because that particular EP has been my creative collaborator for many years, along with the editor, so we are accustomed to working together and don't need to see any pretty visuals to decide if we've got a

solid story. For someone new to the team or the content, I might wait until we have visuals over at least 80 percent of where we want them, before bringing that person in for a review. Here's another situation in which those transcripts we discussed (see Chapters 2 and 11) will come in handy. During a review, if an EP wants to hear an optional soundbite or take, I can easily pull that up from our "best bites" timeline and drop it in to see if it works.

GET APPROVALS

Managing the approvals process is a delicate balance between meeting your original creative vision, not letting your ego get in the way of good ideas, and presenting some risk–benefit analysis for changes that could affect impact or budget. I've found that reviews have become especially challenging since the explosion of social media. I call it the "Facebookification of decision-making." That is, everyone—including those never involved in the project—get to weigh in on a script or edit, and you get the sense that the number of "likes" drives decisions about shot sequences, rather than the all-important narrative arc. When faced with group-think that you don't agree with, going back to your mission statement for the project, how it ties into the expectations you set at the outset, and any strategic goals that are furthered by the production, can often be more helpful than talking about the narrative arc. What I mean by that is, rather than saying, "We've always planned on having José be the main character for the film, as you can see from our casting plan and the original draft of the shooting script," you can say, "Remember the reason we chose José was because you felt he connected strongly with a key demographic of viewers in the 18–24-year-old group, and so cutting him out of the opening sequence might cause us to lose this audience right away." Ah, now you have framed the proposed change in a risk–benefit formula, tied it to strategic goals, and offered your views in a problem-solving context. If they still want to cut José, it's on them to be sure the narrative doesn't lose their key audience.

KNOW THE PLAYERS

Knowing the mission and how it fits into any larger goals gets you part of the way. Knowing the people carries you across the finish line. And there are many different kinds of people you will need to deal with in your work as a producer or director. These five are the ones I seem to come across the most often, and find to be the most challenging:

1. **Button-pushers**
2. **Non-deciders**
3. **People with other agendas**
4. **Big personalities**
5. **Inexperienced leaders.**

I'm no psychologist, but through the years I've worked with hundreds of decision-makers, and found a few ways to work with them more productively on creative projects. I share these in solidarity with you, and hope that being more aware of these human dynamics can help you achieve your creative vision with every project.

Button-pushers are probably the toughest bunch. Often they are not the top dog. In my experience, they are usually someone who aspires to that position and thinks that the best way to get there is to point out others' faults. For some reason, the minute you sit down to a creative meeting, this person is trying to put you on edge. The best way to deal with button-pushers is to turn them into allies. Using the "why" of the project, which is often connected to their performance goals, can be very helpful. Giving them some decisions to make that you can live with is also a great way to diffuse a button-pusher. So, you are presenting your storyboards for the opening sequence, which builds heavily on the company's logo which is green, and the button-pusher says, "I hate green." No worries, what is your favorite color? We can make it that color. Moving on.

Non-deciders are terrifying. I worked with one EP who always wanted to see two or more options for each decision point in a complex

program. This was fine at the storyboard phase. And I provided multiple options for key scene transitions such as on-screen quotes throughout the script. But at some point, decisions must be made, and these affect future decisions. This is when the budget comes to your rescue. Remember the budget? Because you cleverly set up your budget with "dependency" items as we discussed in Chapter 2, you can now say, "We can absolutely record three versions of the narration and show you three different options for the opening title graphic sequence. This will add XYZ to our budget for the title sequence. Attached is a form for you to approve that budget increase. Thanks!" I have never found a non-decider who is willing to pay for the resulting budget increase or defend it to their boss.

People with other agendas are challenging because you often don't know what the other agenda is about. If you have friends in the organization, they can sometimes shed light on this situation. "She's up for her contract renewal in January, and that's why she's lobbying for this new program to put on her resumé." You can't change the person's agenda, but you can try to keep their goals in mind when you introduce an element for approval: "Using this overall graphics look is one way we can make this film stand out from others on this topic." If you have to go head-to-head with this person, and occasionally I've had to take on that awful task, it's helpful to find allies on the executive production team who can help you keep the team's focus on achieving the big-picture mission.

Big personalities can be great allies, because they get stuff done. They often head up departments. They can also suck up the oxygen in a room. For some reason, this always happens when you are at your most exhausted, after shooting on the road for weeks, or editing all night. Buck up, and be your most confident when presenting to a big personality. These folks are confident and direct, and respond best to others who are the same. If you feel strongly that your approach to the script or edit is the right way to go, make your case with confidence. If this person gets to decide, they are going

to make their decision anyway, but your demeanor will cue them as to whether or not they can trust your decisions.

Inexperienced leaders are just what they sound like: people who may have great skills, but haven't had the time to develop them yet in managing a team. Be supportive. Try not to speak down to them, even though you may know buckets more about production. If you can position yourself as an asset, someone who can make them look good, then you are on your way to repeat business. But just be aware that at some point, this person is going to decide they are ready to lead without you, and might ride roughshod over you and your project. They are just making sure their team knows who is in charge, so try not to take it personally. Which is almost impossible, when you have invested heavily in your creative work. Do your best, as this person may be your next great partner or co-producer on a future project.

WRAPPING UP

I HOPE THAT THIS book has encouraged your passion for working with so-called "real people." For those of us producing and directing in this field, whether for documentaries, TV series, educational or advocacy productions, we are lucky enough to spend our professional careers telling stories about and with our fellow human beings. Developing content that relies heavily on the knowledge and experiences of people who are not professional performers has its own unique challenges and rewards. Directing non-professionals requires, in many cases, both a different mindset and slightly altered production strategies. The role of the producer also changes, as putting untrained "talent" before the camera affects scheduling, budgeting, crew, and equipment choices. It affects how a director crafts a scene, and how a producer presents the schedule and budget to executive producers or clients. Through this book, I hope you've gleaned a few tips and tools for the craft of storytelling with real people. Our common goal is always to tell better stories, and to honor people's lives and experiences. It's joyful, and yes, sometimes difficult work. But to quote the lyrics of Ira Gershwin, it's "nice work if you can get it, and you can get it if you try."

APPENDICES

APPENDIX A: CREATIVE BRIEF TEMPLATE (PROJECT NAME)_____

Prepared by: _____

BACKGROUND

Who is our audience?

What do they already know about our subject?

What misconceptions or misinformation might they have about it?

What do we want them to *feel* about the subject?

What do we want them to *do* about it?

CREATIVE

What is the stylistic approach best suited to our content and audience?

What other creative elements or resources should be considered?

What existing branding requirements exist?

What other platforms are contemplated?

TEAM

Who are the internal team on this project?

Who are the external team?

Who is the final decision-maker(s)? [no more than 2]

SCHEDULE

Script treatment due	
First draft shooting script due	
Final shooting script due	
Shoot dates	
Rough cut edit due	
Fine cut edit due	
Final cut for approval due	
Final narration, if any, due	
Music approvals or scoring due	
Audio mixing due	
Color correction due	
Final compressions/outputs due	

APPENDIX B: PRODUCER'S CHECKLIST—APPROVALS

The following are creative production steps that generally will require sign-offs before you can move to the next step in production.

- ✓ **Creative Concept/Treatment**
- ✓ **Estimated Budget**
- ✓ **Schedule**
- ✓ **Concept Storyboards**
- ✓ **Shooting Boards and Narrative Arc**
- ✓ **Production Team/Crew**
- ✓ **On-Camera Appearances (either Interviews, Re-enactors or Direct-to-Camera People)**
- ✓ **Locations**
- ✓ **Final Budget**
- ✓ **Shooting Script**
- ✓ **Editing Script**
- ✓ **Graphics and Titles**
 - Lower thirds—names, titles, spellings
 - Opening titles
 - Closing credits
- ✓ **Rough Cut Edit**
- ✓ **Fine Cut Edit**
- ✓ **Music**
- ✓ **Voiceover**
- ✓ **Final Script (approved for Closed Captioning)**
- ✓ **Final Cut Edit**
- ✓ **Final Audio Mix**
- ✓ **Final Color Grading**
- ✓ **Final Output (digital files in whatever format required)**

The following is a sample approvals form you can use to confirm sign-offs for a project. Feel free to photocopy or adapt it.

DATE	APPROVAL ITEM	APPROVED BY	APPROVED WITH THE FOLLOWING CHANGES

APPENDIX C: ASSET LIST FOR EDIT TEMPLATE

The following is a template you can use to keep track of audio, video, graphics or photo assets during post-production. Feel free to photocopy or adapt it.

ID Info	Description	Source	Credits or Copyright Info

APPENDIX D: PRODUCER'S CHECKLIST—PRE-PRODUCTION

During story development, the reality/documentary producer has a long list of items that need to be strategized and planned for in advance of shooting.

✓ **Story Arc**

- **An understanding of the story trajectory and characters, and how each shoot day fits into telling the story**

✓ **Subjects**

- **Primary and secondary interview subjects**
- **Pre-interviews and research conducted, so you have an understanding of the potential story line**
- **Re-enactors identified, and what potential roles they will play**
- **Direct-to-camera speaker(s) identified, and any talking points planned**
- **Release forms for on-camera subjects**

✓ **Attire & Props**

- **A list of appropriate attire options for subjects**
- **Actual attire for subjects, if they aren't bringing their own**
- **Props such as special pins or materials required for subject to use**

✓ **Location Scouting (Virtual or Physical)**

- **Studio**
- **Exteriors**

- Interiors
- Back-up locations—an interior if your primary location is exterior, for example
- Places for crew to stage/store gear
- Place for hair/makeup/wardrobe to set up
- Places for crew/subjects to eat
- Place(s) for subjects to change wardrobe
- Place for any assistants, handlers, or parents of on-camera subjects to sit and observe out of eyeline of subjects
- Release forms, permits and/or insurance coverage for locations

✓ Bathrooms

- Particularly outdoor locations require scouting this in advance

✓ Parking

- Off-street parking options for crew vehicles
- Parking permits, if required by location

✓ Food & Beverage

- Food for crew and subjects
- Delivery plan
- Snacks—easy to carry, hard to spill

✓ Shoot Specs & Hard Drives

- Clarify shoot plan: frames per second, resolution (i.e., 1920x1080 or 4K) and either progressive scan or interlaced
- A hard drive, laptop, and plan for off-loading and backing up footage throughout each shoot day

✓ **Budget Allocations**

- **Be on the lookout for unexpected situations that could add to your shoot budget, and those that can save you money.**

APPENDIX E: PRODUCER'S CHECKLIST—PRODUCTION

Before heading into the field, the reality/documentary producer has a long list of items that need to be strategized and planned for in advance of shooting.

✓ **Story Arc**

- **Have your shot list ready, including coverage for introducing characters and settings, and "interstitial" sequences for transitions**
- **Be willing to adapt shot list to opportunities and challenges**

✓ **Subjects**

- **Primary and secondary interview subjects**
- **Pre-interviews and research notes**
- **Re-enactors identified for roles**
- **Direct-to-camera speaker(s) identified, talking points or script reviewed/in teleprompter if required**
- **Release forms signed by all on-camera subjects**

✓ **Attire & Props**

- **Props and attire on hand**

✓ **Locations**

- **Double-check locations the night before or hours ahead of crew whenever possible, to avoid any last-minute surprises such as a blocked entrance or lack of parking access**
- **Set up staging/storage area for crew**

- Designate hair/makeup/wardrobe area
- Designate crew/subject meal area
- Set up "video village" equipment away from subject eyeline
- Set up viewing area with monitor for assistants, handlers, or parents of on-camera subjects near video village and away from subject eyeline
- Put signage directing people to bathrooms if you have a large team
- Have signed location release forms or location permits in hand

✓ **Parking**

- Identify/guide crew to appropriate load-in and parking areas for crew vehicles
- Hand out parking permits, if required by location

✓ **Food & Beverage**

- Have pre-ordered food/catering for crew and subjects
- Have cash on hand for tipping food delivery personnel
- Bring snacks—easy to carry, hard to spill

✓ **Shoot Specs & Hard drives**

- Bring hard drive(s) and extra shooting cards on location
- Be clear before the first shot what frame rate (fps), resolution (i.e., 1920x1080 or 4K) and either progressive scan or interlaced
- A hard drive, laptop, and plan for off-loading and backing up footage throughout each shoot day

✓ **Budget Allocations**

- **Know exactly when crew go into overtime**
- **Be conscious of when grip(s) can be setting up the next shot while crew is still taping**
- **Consider breaking crew and subjects into different meal groups to allow some set-ups and taping to continue during challenging days**

APPENDIX F: PRODUCER'S CHECKLIST—POST-PRODUCTION

Before heading into the edit room, the reality/documentary producer has a long list of items that require advance preparation.

- ✓ **Story Arc**

 - Field notes on shooting script and detailed shot list
 - Or . . . best takes and field notes incorporated into editing script
 - Interview transcripts, with best bites/selects noted

- ✓ **Subjects**

 - Digital copies of signed release forms should go with field footage

- ✓ **Locations**

 - Digital copies of signed location releases/permits/insurance forms should go with field footage

- ✓ **Asset List**

 - Identify original materials
 - Archival or stock footage and photos
 - Music assets and licenses
 - Identify any permissions being acquired/still needed for use
 - Correct names, spellings, titles for any lower thirds
 - Correct names, spellings, "courtesy of" information for opening titles and closing credits

✓ **Multi-Platform Needs**

- Review specs for deliverables for broadcast, projection, mobile web, etc. For example, for a broadcast documentary, will there be outtakes of interviews that need to be compiled and output for web playback to a spec such as Vimeo, YouTube or a custom spec?

✓ **Back-up/Archiving Plan**

- Know your back-up plan, which may vary depending on how likely it is that revisions and future updates might be made

APPENDIX G: SAMPLE MINI DOC BUDGET

SAMPLE BUDGET: 3-shoot-day documentary short for museum display (5–8 mins) plus web version

Costs may vary +/– 5%; Actual travel expenses will depend on destinations and the date of flight and hotel bookings

Pre-Production	No.	Rate ($)	Totals ($)
Concept Boards and Story Development–Flat Rate	1	2,500	2,500.00
Scriptwriting/Research–Flat Rate	1	2,000	2,000.00
Crew, equipment, and travel coordination	3	350	1,050.00
Archival photos (others can be acquired for free)	15	100	1,500.00
Subtotal Pre-Production			**$7,050.00**
Location Production: (3) 9-hr shoot days at three locations in continental US	**Days**		
Director/Producer	3	700	2,100
DP	3	750	2,250
HD Camera gear and lenses–C100 or equivalent and prime lens kit	3	750	2,250
DP's basic field lighting kit and monitor	3	350	1,050
Jimmy jib	1	650	650
Dana dolly	3	150	450
Supplemental local lighting and grip package	3	375	1,125
Local grip–9-hr days, no additional OT	3	550	1,650
Local sound person–9-hour days, no additional OT	3	600	1,800
Sound equipment rental, 2 lavs, boom and mixer	3	300	900
Offloading footage to drive on laptop	3	75	225
Subtotal Location Production			**$14,450.00**
Post-Production			
Transcriptions	3	55	165
Editing–4 weeks–weekly flat rate	4	2,300	9,200
After-effects work	10	250	2,500
AP music review/pulls and sound design supervise–days	2	450	900
Producer/Director transcript review/edit Planning–days	2	650	1,300
Producer/Director working with editor–4 weeks flat rate	4	3,250	13,000
Producer/Director in client team meetings/reviews–days	3	700	2,100
Sound design–hrly	16	250	4,000
Colorist–hrly	8	275	2,200
Stock music–flat buyout for web distribution and museum display up to 6 mos	1	800	800
LTO project back-up	1	250	250

APPENDIX G
SAMPLE MINI DOC BUDGET

Compressions for web and museum specs	4	75	300
Subtotal Post-Production			**$36,715.00**
Pre-Production			$7,050.00
Production			$14,450.00
Post-Production			$36,715.00
SUBTOTAL BEFORE TRAVEL			**$58,215.00**
Travel Estimate (from next page)			**$9,366.00**
TOTAL INCLUDING ESTIMATED TRAVEL			**$67,581.00**

TRAVEL ESTIMATE: Producer and DP: 2 nights each in 3 locations based on Chicago, Vegas, and NYC from Washington, DC (Picking up local sound, additional lighting, and a grip)

LOCATION 1	No.	Rate ($)	Totals ($)
R/T airfare based on Chicago (2 people)	2	671	1,342.00
Baggage overages for gear	1	400	400.00
Per diem Location 1 (2 people, 2 days each)	4	72	288.00
Per diem Location 1 Crew (2 people, 1 day's coffee/snacks, lunch, dinner)	2	40	80.00
Hotel Location 1 (2 nights, 2 people)	4	365	1,460.00
Ground transport Location 1—van rental	2	95	190.00
Airport Parking and mileage	3	75	225.00
Miscellaneous tips, hotel and street parking for vehicles	3	50	150.00
LOCATION 2			
R/T airfare based on Vegas (2 people)	2	450	900.00
Baggage overages for gear	1	375	375.00
Per diem Location 2 (2 people, 2 days each)	4	72	288.00
Per diem Location 2 Crew (2 people, 1 day's coffee/snacks, lunch, dinner)	2	40	80.00
Hotel Location 2 (2 nights, 2 people)	4	255	1,020.00
Ground transport Location 2—van rental	2	130	260.00
Airport parking and mileage	3	75	225.00
Miscellaneous tips, hotel and street parking for vehicles	3	50	150.00
LOCATION 3			
R/T train DC to NY (2 people)	2	365	730.00
Per diem (2 people, 2 days each)	4	72	288.00
Per diem local crew (2 days' coffee/snacks, lunch, dinner)	1	50	50.00
Hotel NYC (1 night, 2 people)	2	385	770.00
Ground transport taxis	1	75	75.00
Miscellaneous tips	1	20	20.00
Subtotal Travel			**$9,366.00**

GLOSSARY

Boom The pole or telescoping arm on which a microphone is mounted. The term is often used by film crews to describe the entire microphone and pole set-up.

B-roll Supplemental footage that helps to support the main story. B-roll shots commonly include establishing shots as well as shot sequences that depict the content of an interview or narration, as well as help to cover any edits in that primary footage.

Dolly Equipment designed to move the camera smoothly. A dolly can be a simple platform that runs on track, or a more elaborate cart with wheels.

DP Director of Photography (also DOP) who oversees camera crews on a production. On smaller-scale productions, s/he often also serves as the lighting director, and even the director.

DSLR A digital single-lens reflex camera, also known as a digital SLR, which uses a digital imaging sensor in addition to the optics and mechanisms of a single-lens reflex camera. Some, but not all, DSLRs shoot video as well as still photographs.

EP Executive Producer, who oversees a television or film production and is often responsible for its budget and distribution.

Fine Cut A refined version of the film that includes the primary story as well as supporting elements such as b-roll, music, voiceover, and graphics. A fine cut may not include final audio mixing or color correction, depending on the workflow of the production.

FPO "For placement only" or "For position only." The expression originates in graphic design and printing, and has carried into film production, where it means images that are temporary and low-resolution images (and sometimes watermarked, if they are from stock footage or photo providers) which are placed into the editing timeline in order to complete the rest of the editing. These temporary images are then replaced

with high-resolution images, properly licensed so that the watermark is not present, for the final version.

Grip A rigging technician who builds and maintains the equipment that supports cameras and lighting equipment.

HMI **H**ydrargyrum **M**edium arc **I**odide lights have the color temperature of daylight, 5,600 degrees Kelvin, and thus are used for shooting in daylight conditions.

Lav Short for lavalier, this small microphone can be attached to a person via a clip to their shirt or collar and can be conveniently hidden or minimized from view, and is either attached to a wireless transmitter or cabled directly to the sound mixing device.

Magic Hour Also known as "Golden Hour," when the sun is closest to the horizon and casts a warm golden glow on the scene. It is not literally an hour long, as the length of time for this circumstance depends on one's latitude and the time of year.

Mic Slang for microphone.

OTS Over the Shoulder shot, which describes the vantage point of the camera, which is pointing at the subject from behind the shoulder of someone speaking to the subject. Dialogue often cuts back and forth between over the shoulder shots, thus representing the two points of view in a conversation.

Post Short for post-production, and referring to the aspects of putting together a film after the shoot is completed, including editing, graphics, music scoring, audio mixing, and color-correction.

POV Point of view, referring to the positioning of the camera as if it were a person seeing the scene from their vantage point.

Rough Cut A draft of the film that focuses on the big picture story arc, without all of the supporting details such as music and b-roll.

Single	A camera shot framed around just one on-camera subject.
Soundbite	A short statement excerpted from a longer audio clip, from an interview or other on-camera recording.
Soundie	Slang for sound operator.
Stinger	A professional-grade extension cable.
String-out	A first draft of the film that focuses exclusively on the story arc, and often is just a series of soundbites "strung out" in the anticipated order.
Two-shot	A camera shot framed for two on-camera subjects.
Video Village	The production area set aside away from the main shooting subjects, with viewing monitors and chairs for the director and other production personnel, and which sometimes feels like a small village once everyone gets settled in.

BIBLIOGRAPHY

BOOKS AND PERIODICALS

Bernard, Sheila Curran. *Documentary Storytelling*. New York: Routledge, 2015.
Foster, Jeff. *The Green Screen Handbook: Real World Production Techniques*. Burlington, MA: Focal Press, 2015.
Grossman, Seth. "Donald Trump, our Reality TV Candidate." *The New York Times*, September 27, 2015.
Zinsser, William. *On Writing Well*. New York: HarperCollins, 2006.

FILM AND TELEVISION

Cain's Arcade, directed by Nirvan Mullick. Premiered on YouTube, April 9, 2012.
Civil War 360, directed by Molly Hermann. Washington, DC: Smithsonian Channel and The Biscuit Factory, 2013.
The Devil's Advocate, directed by Taylor Hackford, story by Andrew Neiderman, screenplay by Tony Gilroy and Jonathan Lemkin. Los Angeles, CA: Warner Brothers Pictures, 1997.
The Dick Van Dyke Show, Season 4, *Episode* 19 "*Boy #1, Boy #2*", *created by Carl Reiner, directed by Jerry Paris. Los Angeles, CA: CBS,* 1965.
Fracking: Weighing the Risks, directed by Pauline Steinhorn. Owings Mills, MD: Maryland Public Television, March 20, 2012.
Gone Girl, directed by David Fincher, screenplay and novel by Gillian Flynn. Los Angeles, CA: 20th Century Fox, 2014.
Her Aim Is True, directed and produced by Karen Whitehead. Fur Face Film, premiered May 2013.
An Inconvenient Truth, directed by Davis Guggenheim, screenplay by Al Gore. Beverly Hills, CA: Participant Media, 2006.
The Italian Americans. TV documentary, written and produced by John Maggio. Maggio Productions, ARK Media, and WETA Washington. Washington, DC: WETA, 2004.
The Roosevelts: An Intimate History, directed by Ken Burns. Florentine Films, premiered September 14, 2014.

ONLINE CONTENT

Steve Audette, Editor, Workflow Tutorials https://vimeo.com/17502817 and https://vimeo.com/95543071

Eventual Millionaire podcast series, founded and hosted by Jaime Tardy, http://eventualmillionaire.com/millionaire-case-studies/

Robert Hardy, "How to Slate Like a Pro (Plus How you Definitely Shouldn't Slate, Like Ever)," No Film School Blog, June 2, 2015, http://nofilmschool.com/2015/05/how-slate-pro-plus-how-you-definitely-shouldnt-slate-ever)

Philip Hodgetts and Dr. Gregory Clarke (Lumberjack System) http://lumberjacksystem.com/

Movie Magic screen shot created using Movie Magic Scheduling software owned by DISC Intellectual Properties, LLC dba Entertainment Partners. For more information, see www.ep.com/scheduling/

Simon Sinek, TED talk "Start with Why." YouTube video posted September 29, 2013, www.youtube.com/watch?t=1&v=sioZd3AxmnE

Wave Agent (Sound Devices, LLC) www.sounddevices.com/support/downloads/wave-agent

BROADCAST INTERVIEWS

Asif Kapadia, interview by Terry Gross, *Fresh Air*, NPR, July 8, 2015.

PERSONAL INTERVIEWS BY THE AUTHOR

Steve Audette, Editor, phone interview, October 12, 2015.

Nutan Chada, Producer/Director, Defense Logistics Agency CIV Public Affairs, phone interview, September 24, 2015.

Richard Chisolm, Director/Director of Photography, in-person interview, May 13, 2015.

Lisa Feit, Post-Producer/Writer, phone interview, February 13, 2015.

Kim Foley, Stylist, phone interview, May 8, 2015.

Alex Gollner, Final Cut Pro X Editor/Plugin Maker, emails, October 14–16, 2015.

Michele Gomes, Director of Photography/Producer, InterChange Media, phone interview, September 23, 2015.

BIBLIOGRAPHY

Matt Gottshalk, Director of Photography, in-person discussion, July 14, 2015; emails, September 14, 2015.

Molly Hermann, Director/Producer, phone interview, July 13, 2015.

Philip Hodgetts, Content Metadata Expert/Writer/Software Developer, emails, October 14–16, 2015.

Maxim Jago, Editor/Director/Author, email discussions, September 23–28, 2015.

Cheryl Ottenritter, Sound Designer and Co-Owner, Ott House Audio, email discussion, July 20, 2015.

Pauline Steinhorn, Writer/Producer/Director, in-person interview, September 26, 2015.

Jaime Tardy, Founder/Host, *Eventual Millionaire* podcast, phone interview, May 14, 2015.

Benjamin Adams Trueheart, Producer, phone interview, February 13, 2015.

INDEX

INDEX

actors 36–7
Adobe 158–9
Adobe Live Logger 153
agendas 174
American Society of Media Photographers (ASMP) 64–5
Amy (Kapadia) 10
Animal Planet 73
antagonists 9
anti-Semitism 129
Appalachia documentary 15–16, 51
approvals 55, 172
architectural contracts 44
archival materials 161–4
asset lists *183*
Association of Independent Commercial Producers (AICP) 42
Astrof, Jeff 129
Attention Deficit Hyperactivity Disorder (ADHD) 146
Audette, Steve 155, 158
audiences 69–70, 103–4
audio 31–2, 52, 153–4
audio-only pre-interviews 10
automated slider *80*
Avid 157–8

babies 39–41
backdrops 60
background research 19–20
beamsplitter glass 110–11
Bernard, Sheila Curran 151
"Best of" series 64
biases 20
bidding 42–7 *see also* budgets
Bieber, Justin 87–8
big personalities 174–5
big-picture answers 137
blanket clauses 64
body language 132, 147
boom microphones 117, **195**
boundaries 145

breaks in filming 30, 76
b-roll (supplemental footage) **195**; coverage 120; ideas for 21; for interviews 139–40; planning 41–2; re-enactments 13, 117–19, 121–3; shooting schedule 76–7
budgets: bidding 42–7; sample *192–3*; schedules 25–6; using actors 36
bullet points 111–12
Burns, Ken 69–70
business days 44 *see also* timings
button-pushers 173

Cain's Arcade (documentary) 71, 73
camera-in-motion shots 79–80
cameras 37–9
"cast against type" 60
casting 9–16; children 11–12; direct-to-camera read 12–13; pre-qualifying interviews 9–11; re-enactments 13–15; unwise to 15–16
celebrities 87–8, 146–7
Center for Media & Social Impact (CMSI) 67
central challenges 72
Chada, Nutan 55–7
challenging interviews 143–8; children 143–4; languages 147–8; nervous subjects 145–6; traumatic subjects 144–5; VIPs 146–7
challenging locations 54–9
challenging topics 133–4
charisma 10
children: breaks in filming 30; casting 11–12; direct-to-camera delivery 109; familiar spaces 144; interviews

143–4; pre-interviewing 11–12, 22; schedules 39–41; talent releases 64–5
Chisolm, Richard 14, 83–4, 117, *122*
Civil Rights Movement 73
Civil War 360 (Smithsonian Channel) 77–8
client relationships 167–75 *see also* relationship-building processes
climaxes 73–4, 136–7
clothing 21, 26–9
coaching 90, 104
color-coding transcripts 157
community-sourced wiki 53–4
compensation 11
conclusions 74, 137
construction 44
continuity savers 78–9
contracts 44
controlling the set 133
copyright 66
cost-plus budgets 42, 44
costs *see* budgets
creative brief 167–9, *170*, *179–80*
crews 97–101; educating 84–5; expectations 98; food 34, 100–1; hiding 112–13; locations 53; production costs 29–30; real people becoming 119 *see also* teams
cultural barriers 147–8

Dana dolly 79–80
dance of the interview 129
day rates 43 *see also* budgets
decision-makers 169–71, 172, 173
De Laurentiis, Giada 108
Dellaccio, Jini 70
Department of Defense 55–6
dependency schedule 44

203

INDEX

design concept 44
devil's advocate 113
Dick Van Dyke Show (CBS) 26
digital media 53, 120, 163–4
DiPalo, Lou 33
Director of Photography (DP) **195**
directors 83–4
direct-to-camera delivery 102–14; casting 12–13; children 109; coach to the crowd 104; difficulties 102; environment 105–6; experienced speakers 103–7; framing options 106; inexperienced speakers 107–9; natural delivery 109; privacy 104; professionals 36–7; standing deliveries 106–7; virtual environments 92 *see also* teleprompters
disaster-planning events 59
discussion circles 122
Documentary Filmmakers' Statement of Best Practices in Fair Use (CMSI) 67
dolly shots 79–80, **195**
driving 34
DSLR (digital single-lens reflex camera) 35–6, **195**

Ebola crisis 61–2
editing: asset lists *183*; processes 151–2; soundbites 157; workflow strategies 150–64
editors 151
educational outreach pieces 92
establishing shots 71
Eventual Millionaire (podcast) 75
executive producers (EP) 41, 87–9, **195**
expectations 98, 169
experts 146–7

exposition 70–1
external factors 119
eye contact 132

"Facebookification of decision-making" 172
"fake moments" 14 *see also* re-enactments
family photos 21
Feit, Lisa 74, 155
field interviews 60–2
field notes 153
Final Cut Pro X 159
Fincher, David 92
fine cut **195**
first-person moments 19
fixed-price budgeting 42, 44, 46
Flay, Bobby 108
flexibility 148
Flickr 53
Foley, Kim 86
food 34, 100–1
food-safety stories 133–4
For Placement Only images (FPO) 162, **195–6**
Foster, Jeff 94
Foursquare 53
Fracking: Weighing the Risks (MPT) 58
framing options 106
freelance teams 97–8
friendly environments 91
full-scale re-enactments 123–5
future-proofing archives 163–4

gatekeepers 20–1
gear 53, 112–13
Gone Girl (film) 92
good buddy pictures 73
Google Maps Street View 53
Gosselin, Kate 25
Gottshalk, Matt 29, 118
Green Screen Handbook (Foster) 94
green screens 60, 92–4

grips 29–30, 99, **196**
Gross, Terry 10
Grossman, Seth 9–10
group-think 172
guardians 11, 144 *see also* parents

hair and make-up 86–7
handlers 87–9
hand off audio notes *154*
Harrington, Richard xvii–xix
Healers and Healing (InterChange Media) 72
Health Insurance Portability and Accountability Act (HIPAA) 55
Her Aim Is True (documentary) 70
Hermann, Molly 77–8, 123–5
historical re-creations 123
HMI (Hydrargyrum Medium arc Iodide lights) 53, **196**
hobbyist re-enactors 123
homework 19–20
hooks 69–71, 136
hopscotch group 89, *90*
hospitals 55, 121–2
hostile witnesses 91
human connections 22 *see also* relationship-building processes
hybrid budgets 42, 46–7

identification 56
images 52 *see also* locations
impromptu interviews 16
Inconvenient Truth (film) 74
inexperienced leaders 175
inexperienced subjects 145–6
informal conversations 132
inner performer 89
insurance 53
InterChange Media 72
internal training productions 92

204

INDEX

International Alliance of Theatrical Stage Employees (IATSE) 43
internet 64
"interstitial" sequences 30–1, 78–9
interviewers 129–30
interviews 129–40; body language 132; b-roll 139–40; building rapport 131–2; challenging subjects 143–8; challenging topics 133–4; children 143–4; climaxes 136–7; conclusion 137–8; extra questions 139; eye contact 132; hooks 136; multi-character stories 134; preparation 18–22, 130–1; story arc 135; talking points 134–5; unpredicted moments 132–3
investigative stories 57–8
iStripBoard (Apple) 48
Italian Americans (PBS documentary) 33

Jago, Maxim 159
jewelry 28
Joy, Karen 72

Kapadia, Asif 10
key phrases 32
knowing the players 173–5

language 147–8
lav (lavalier) **196**
learning styles, interviewees 136
legal issues 53
licensing restrictions 161–2
LightTrac app 54
Liston, Crystal 72
live events 59
location agreements 53, 63–4
locations 34, 51–67; advance logistical work 57; challenging 54–9; establishing shots 71; no choice 65–6; online and digital tools 53–4; rights issues 66–7; scouting 51–4
logistics 52
Lumberjack System 159–60

macro stories 75–6
Magic Hour **196**
make-up artists 86–7
managing stock 161–2
Marines 57, 86
Marshall, Roseda 61–2
Maryland Public Television (MPT) 58
meals 34, 100–1
medical situations 55, 121–2
memorizing copy 110
mentoring 101
military environments 55–7
millionaires 75
mini-documentary budgets 192–3
mini-sliders 80
mission, defining 167–9
Movie Magic Scheduling (Entertainment Partners) 47, 48
multi-character stories 134
multiple narratives 75–6
multiple shots 37–9

narrative fiction 17
narrative filmmaking 120
natural delivery 109, 111
nervous subjects 131–2, 145–6
non-actors: breaks in filming 30; reasons to use 117–18; re-enactments 14, 37; stress of the crew 30; teleprompters 110
see also real people
non-child-friendly environments 144

non-deciders 173–4
note-taking tools 153–4

"off-script" notes 153
on-camera clothing 26–9
online tools, location production 53
On Writing Well (Zinsser) 136
OpenStreetMap 53–4
Optical Low Pass Filters 29
"opt-out" policies 55
organizations, strategic plans 169–71
Ottenritter, Cheryl 32
overhead costs 43–4
over the shoulder shot (OTS) **196**

paper edits 152
parents: concerns 11; pre-interview call 22; sightlines 109, 144
performance 26
permissions 18–19, 55–6
Photopills 54
planning: schedules 25; stories 69–81
playing dumb 113
point of view (POV) **196**
Pool Master (Animal Planet) 73
Portable Document Format (PDF) 162
post-production checklist 190–1
practicing 108–9, 112
pre-interview calls 11, 18, 21–2
pre-interviewing 11–12, 15–16, 130
Premiere Pro video editing software (Adobe) 158–9
pre-production checklists 184–6
pre-qualifying on-camera subjects 9–11
"pre-scripting" 81

205

INDEX

primary sound 122
privacy 104
producers: approvals checklist 181–2; client relationships 167; editorial processes 151; post-production checklist 190–1; pre-production checklist 184–6; production checklist 187–9; role 83
production assistants (PAs) 29, 99
production checklist 187–9
production contracts 44
production schedule 26
production teams 97
project proposals 168
prompters *see* teleprompters
protagonists 9

Q&A practice 109
questions 130, 139

reality TV shows 9–10
real people 83–94; b-roll coverage 120; as crew 119; green screens 94; inner performer 89; part of team 83–4 *see also* non-actors
recordings 18–19, 156
re-enactments 117–26; budgets 117; casting 13–15; DP's tools 124; full-scale 122–4; shot list planning 77; staged 36–7
rehearsing 108–9, 112
relationship-building processes 10–11, 17, *122*, 131–2 *see also* client relationships
repetition 26
rephrasing answers 138
Request for Proposal (RFP) 42
reviews 171–2
rights to film 66–7
Ronin camera stabilizers 80

Roosevelts (documentary) 69–70
Rough Cut **196**

scenarios 125–6
scene lists 152
schedules 25–6, 39–41
scheduling software 47–8
school district disaster-planning events 59
schools 55
"scripted television" reality shows 74
ScriptE™ 153
scripts 80–1
script supervisor software 153
ScriptSync™ 158
sculptures, rights to film 66–7
self-consciousness performances 26
sensitivities 84–5
"shifty eye syndrome" 104
shooter-audio tech-directors 100
shooting scripts 81
shoot logistics 21
shot sequences 76–8, 120
Shymanksy, Nick 10
side-to-side action 79–80
simultaneous set-ups 35–6
Sinek, Simon 168
single **197**
single person production 100
60-Minutes-type news interviews 91
Skype interviews 9–10
slates 154
smiling 108
Smith, Sheila *56*, 89
Smithsonian Channel 77–8
social media 172
sound 52 *see also* audio
soundbites 136, 157, **197**
Sound Devices 156
sound notes 153

speaking 117
"spy-rigging" 57
staged discussions *121*
"stage moms" 11
stand-alone scenes 125–6
standing deliveries 106–7 *see also* direct-to-camera delivery
Steadicam™ 80
Steinhorn, Pauline 57–9
stingers **197**
stock assets 161–2
story arc 69, 135
storytelling: "interstitial" sequences 30–1; mapping 155–60; planning 69–81; trust 10
strategic plans 169–71
string-out **197**
stripboards 47–8
studio location 62–3
stylists 145–6
subtitles 148
supplemental footage *see* b-roll (supplemental footage)
support staff 147
surprises 22
sympathetic environments 91
syncing scripts 157–60

tagging footage 32
talent releases 64–5
talking points 134–5
talking while doing 32–4
Tardy, Jaime 75
teams 85, 98–9 *see also* crews
technical processes interview topics 133–4
teen alcohol abuse documentary 60–1
teleprompters 110–11, 153 *see also* direct-to-camera delivery
Television, Internet & Video Association (TIVA) 66
terminology 85 *see also* glossary

206

INDEX

testimonials 112–14
thanking 101
thumb drives 121
timecodes 156, 157
time-lapse sequences 78
timings 43; business days 44
tourism offices 53
transcripts 18–19, 32, 155–60
transitions 78–9
translators 148
traumatic subjects 144–5
travel 53
Truehart, Benjamin Adams 10
trust 10
two-shot **197**

unions 43
unpredicted moments 132–3
unspoken rules 99

validators 19–20
video cameras 29
video village **197**
Vietnam Veterans Memorial 66
VIPs 146–7
virtual environments 92 *see also* green screens
visual assets 21
voice recognition 157

"walking through the door" shot 119

welcoming environments 91
Whitehead, Karen 70
"why" and "how" questions 136
wireless microphones 117
Women in Film & Video (WIFV) 66
words, difficulties with 110
wrapping up interviews 137–8
wrong answers 113–14

Yanes, Isabel *158*

Zinsser, William 136

Taylor & Francis eBooks

Helping you to choose the right eBooks for your Library

Add Routledge titles to your library's digital collection today. Taylor and Francis ebooks contains over 50,000 titles in the Humanities, Social Sciences, Behavioural Sciences, Built Environment and Law.

Choose from a range of subject packages or create your own!

Benefits for you
- Free MARC records
- COUNTER-compliant usage statistics
- Flexible purchase and pricing options
- All titles DRM-free.

Benefits for your user
- Off-site, anytime access via Athens or referring URL
- Print or copy pages or chapters
- Full content search
- Bookmark, highlight and annotate text
- Access to thousands of pages of quality research at the click of a button.

REQUEST YOUR **FREE** INSTITUTIONAL TRIAL TODAY

Free Trials Available
We offer free trials to qualifying academic, corporate and government customers.

eCollections – Choose from over 30 subject eCollections, including:

Archaeology	Language Learning
Architecture	Law
Asian Studies	Literature
Business & Management	Media & Communication
Classical Studies	Middle East Studies
Construction	Music
Creative & Media Arts	Philosophy
Criminology & Criminal Justice	Planning
Economics	Politics
Education	Psychology & Mental Health
Energy	Religion
Engineering	Security
English Language & Linguistics	Social Work
Environment & Sustainability	Sociology
Geography	Sport
Health Studies	Theatre & Performance
History	Tourism, Hospitality & Events

For more information, pricing enquiries or to order a free trial, please contact your local sales team:
www.tandfebooks.com/page/sales

 The home of Routledge books

www.tandfebooks.com